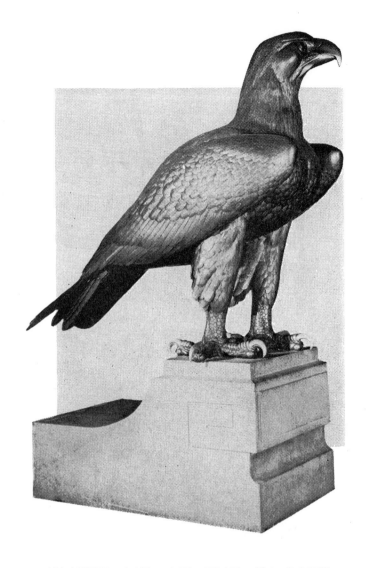

"MEET ME AT THE EAGLE"
In the John Wanamaker Grand Court

From the 1947 brochure *Welcome to Philadelphia and John Wanamaker. Courtesy of the author.*

Wanamaker's

MEET ME
AT
THE
EAGLE

Michael J. Lisicky

Charleston London

THE
History
PRESS

Published by The History Press
Charleston, SC 29403
www.historypress.net

Copyright © 2010 by Michael J. Lisicky
All rights reserved

First published 2010

Manufactured in the United States

ISBN 978.1.59629.008.2

Library of Congress CIP data applied for.

To my father, Anton, who allowed me to be my own person.

CONTENTS

CONTENTS

Foreword

By Dinty W. Moore

T he classic gargantuan department store is as much about fantasy as it is about commerce, though the former has always diligently served the latter. We, the unsophisticated American consumers of the early to mid-twentieth century, still reeling from the advent of electricity and horseless carriages, upon finding ourselves ushered into a veritable Versailles of light, color, sound and aroma (candy counters, hot cashew nuts, perfume, talc, piles of clean, folded cotton linens), are hard-pressed to leave without gathering at least some small bit of this daydream into our glossy shopping bag. We have seen the future of American consumption, and we want some.

The stringed sacks, with elegant logo, are part of the fantasy. Even if we could only afford one pair of socks, a greeting card or a three-pack of handkerchiefs, we have the bag on our arm as we head for the trolley, signaling to our fellow citizens: we shopped well!

Wanamaker's is the store of my dreams. Literally.

I remember as a boy falling asleep to a particular and detailed reverie: every other single soul on the planet had somehow disappeared into the vapor and only I had survived. (Yes, I was a lonely kid, with lonely fantasies.) Where would I go? What would I do? How would I, only eight years old—with no domestic skills, no knowledge of the world—manage to survive on my own?

The department store, of course.

There was an entire floor devoted to furniture, individual rooms, side by side, ready for occupancy. And all manner of beds, already made. If I tired

of one bed, tore the sheets or spilled chocolate milk on my blanket, I could just move on to the next bed—for years.

There was food enough, even without going up to the ninth floor's Crystal Tea Room. A boy could live pretty well on pretzels and chocolate creams, couldn't he?

Had I been a little older when this melodramatic fantasy played out in my brain, I would have willed a young woman to survive alongside of me, pig-tailed with a plaid skirt, and eventually (once I conquered my acute embarrassment), we would have started a new race of men. The Department Store People.

The Department Store People would wear fresh clothes each and every day.

We would create a model railroad (linking together every last piece of track found in the toy department) to run the entirety of the store, even up and down the escalators. The Department Store People Railroad would deliver candy, pretzels, soda pop and Mad magazines to the far-flung ends of the store, where various versions of us would be busy making gigantic Erector set treehouses, or playing serial games of Go to the Head of the Class (because our children would need school of some sort) or watching fourteen televisions at once.

We would probably have to clear away at least one end of one floor—certainly we could do without ladies' unmentionables—to create space for our weekly DSP League baseball and football games. Given all of the sporting goods equipment available to us, it would be a shame not to play.

I suppose, eventually, our children would want children of their own, so the next generation of Department Store People, once the numbers grew too large, would have to move out and occupy other stores.

Perhaps they would ride bikes to New York City, and occupy Macy's.

But that's getting too far ahead. In the near term, my new race of men could survive anything, even nuclear winter, inside of Wanamaker's. The sheer bulk of it: one entire downtown Philadelphia city block, across from City Hall, twelve floors above ground and two more below, nearly two million square feet. So big it needed its own post office and radio station. The walls made of granite.

John Wanamaker wanted to make a statement, apparently. And he did.

Barred from enlistment during the Civil War because of a nagging cough, he threw his considerable energy into the art of selling and managed to alter the customer–storekeeper relationship forever. Wanamaker pioneered

truth in advertising (though he wouldn't advertise on Sundays, the day of rest). He was first with a "return it for your money back if not satisfied" policy. He brought us White Sales and a firm price tag, with no haggling. His first Philadelphia store introduced electrical illumination, telephones and pneumatic tubes to the retail world.

But it is not John Wanamaker's first store that I remember so well—it is his masterpiece, that mammoth granite block of Brotherly Love and Commerce, the Florentine flagship at Thirteenth and Market, dedicated by President William Howard Taft on December 30, 1911.

I worked at the downtown store, for two days.

Day one was training, and I was thrilled to discover an entire second world hidden behind the false showroom walls. The Wanamaker's that shoppers knew, it turned out, was merely a colossal box inside of an even more colossal box. Along all four outer walls, ringing all nine retail floors, was another layer, an exoskeleton of hidden stairwells, offices, storerooms, break rooms—dusty and colorless—in perfect contrast to the public spectacle. A city within a city within the city of Philadelphia.

My second day, I folded sweaters.

My third day, I found a better job.

But I never fell out of love for the place. I never stopped yearning to say to my friends, "meet me by the Eagle," meaning (as everyone knew) the 2,500-pound bronze bird in the marble-clad atrium.

Joan Didion once wrote, "Of course great hotels have always been social ideas, flawless mirrors to the particular societies they service."

So true. And true as well of the classic department store.

Wanamaker's embodied the aspirations of countless Philadelphians, just as Macy's did for millions in New York City, and for the endless crowds of tourists who stepped off the bus and headed straight for Herald Square. Chicago had Marshall Field's, San Francisco had the Emporium and London had Harrods.

But times change. We are shopping now from our smart phones, awaiting delivery from remote, unseen warehouses, meeting one another on Facebook rather than under the big bronze clock. If you see that perfect sweater, please tweet about it. Send me the link.

Dinty W. Moore currently lives in Athens, Ohio, where he directs Ohio University's bachelor's, master's and doctorate programs in creative writing.

FOREWORD

By Louise Wanamaker

What made Wanamaker's so special to the people of Philadelphia was the obvious: the eagle, the music, the attitude of the people who worked there. They actually wanted to help the customer. They certainly don't do that now. It was also the presentation of the merchandise that made the store so special.

I always thought that it was fascinating to be able to go to one store and get everything. The store had such a wide variety of merchandise. Pots and pans, hats, dresses, toys, televisions—you could get it all in one building. I always liked the House Furnishings department and remember being fascinated by the refrigerators. It was a wonderful store.

I first met John up in Maine where we both summered with our grandmothers. I was seventeen when we got engaged, and we were married in 1940. In September of that year, I worked at the store as a sales girl. I just wanted to see what it was all about. In those days you had to wear stockings, high heels and a black dress. It was interesting. Every day you had to get dressed up and commute to town. But the salary was so bad that it hardly paid for lunch. It was awfully hard work.

It was wonderful being married to a Wanamaker. My husband knew every single elevator man's name and every salesperson by first name. Wanamaker's was a passion for my husband and for my son. Later on, my husband tried very hard to hold the company together. He didn't want to sell or disperse it. But after it was sold he realized that it was the best thing for the store. I'm glad it was sold because I wouldn't have wanted to sit with it while it went down. People were staying in the suburbs. They were shopping

at boutiques in the country. It seemed that department store shopping was over—our time was over.

I never went back into the stores after they were sold. I just didn't want to look at it again. Nostalgia, I guess. I'd rather remember it full of people, customers and merchandise. I'm glad the Main Store is still open. I think it would be a shame for it to be closed. Whenever anybody comes up to me and tells me that "they miss the store," I just agree with them and say, "So do I."

January 2010

Acknowledgements

I would like to thank the following people who helped honor this Philadelphia institution. Dinty W. Moore, a literary treasure who perfectly put the Wanamaker's mystique to words; Louise Wanamaker, for trusting me and giving me some personal insight on what it was like to be a Wanamaker; Christopher Kellogg, who helped me fill in many blanks in the Wanamaker story; William Zulker; Herbert Ershkowitz; Joel Spivak; Mercia Grassi; Richard Hauser; Bruce Kopytek, Christian Colberg; Matthew Truch; Ray Biswanger of the Friends of the Wanamaker Organ; and Curt Mangel. Big "thank yous" go to Philadelphia legends Sally Starr, Trudy Haynes and Pat Ciarrocchi.

Thanks and appreciation goes to the staffs of the Historical Society of Pennsylvania, Temple University's Urban Archives Collection, Free Library of Philadelphia, Wilmington Public Library and Michael Seneca of the Athenaeum of Philadelphia. Special thanks goes to Governor Edward G. Rendell and the Office of the Governor of Pennsylvania; former Philadelphia district attorney Lynne Abraham; Mayor Michael A. Nutter, Jordan Schwartz and the Office of the Mayor of the City of Philadelphia; Philadelphia city councilman Frank L. Rizzo Jr.; and Greta Greenberger and the Tour Office at Philadelphia's City Hall. Special thanks goes to Jane Von Bergen and the staff at the *Philadelphia Inquirer* and the *Philadelphia Daily News* and to Jan Whitaker, who continues to guide me through my unusual interests.

As always, this book could never have happened without the love and support of my wife, Sandy, who helps make my books readable and helps me battle my overuse of prepositions. And to my daughter, Jordan, who continues to let her father obsess about department stores and other endangered things.

INTRODUCTION

When people living in Philadelphia began asking me how to spell the name Wanamaker, I realized that it was time to write this book. I grew up in Cherry Hill, and I never went into Center City without at least walking through the store. It seemed like Wanamaker's was Philadelphia, just like cheese steaks and string bands. The store was as big as they come but just in case you got lost or had an appointment with someone, all you had to do was meet them at the Eagle.

Philadelphia has been a notoriously competitive retail market and it never had a shortage of department stores. Each of the hometown stores had its own identity. Strawbridge's had its Seal of Confidence; Lits had its collection of iron-front buildings advertising "Hats Trimmed Free of Charge"; Gimbels had its Thanksgiving Parade; and Wanamaker's had its Eagle.

My mother loved to shop—or should I say browse. I can't say that Wanamaker's was my mother's favorite store; she shopped there but not exclusively. Her loyalties tended to lean toward Strawbridge & Clothier, the chief rival of Wanamaker's. My mother came from a very modest upbringing, and she seemed to view Wanamaker's as the store for the upper class. Whether that was actually the case, it never stopped me from going there, at least to just walk around.

I always had trouble calling the store Wanamaker's. To me, it was John Wanamaker. That's what the name on the building said and that was the name of the man who helped to perfect the American department store. Wanamaker was truly an American icon. In addition to operating large emporiums in Philadelphia and New York, he was a pillar in his church. His

religious devotion spilled over into the operation of his stores. That, along with his love of fine art and culture, set Wanamaker's apart from not only the local competition but also the competition in many other American cities.

The store's logo was the founder's signature and it seemed to have the same authority as that of John Hancock's. The name John Wanamaker seemed to command quality, confidence and heritage. It was befitting of a store that was a regal neighbor to Philadelphia's City Hall. Its main aisle was one of Philadelphia's most famous—and most beautiful—passageways. Whenever celebrities came to town, they came to Wanamaker's. And when generations of Philadelphians celebrated Christmas traditions, they went to Wanamaker's.

By the time I was a kid, Wanamaker's was getting a little dusty and a little dingy. In the 1970s, Strawbridge's overtook Wanamaker's as the number one department store in Philadelphia in terms of sales, but that wasn't the only issue facing Wanamaker's. Out-of-town companies were beginning to take root in the area. Stores like Bamberger's and Bloomingdale's were courting Wanamaker's customers, and those stores were winning. The family wanted out, and new owners were never sure what to do with the stores. Neither did Philadelphia; the city still wanted a store named Wanamaker's—residents just didn't want to shop there.

There are a number of books written about the man John Wanamaker but not about the store, which dates back to 1861. It was the first store to refund money for returned merchandise; the first store to open a restaurant; the first store to have a telephone exchange; and it was one of the first American stores to adhere to the phrase the Customer Is Always Right.

Wanamaker's was part of my childhood. Whether it was a trip to Center City or just the Moorestown Mall, the name John Wanamaker will forever be a part of me. Today, the doors of the Center City store are still open. The building now houses another retailer but for many Philadelphians it's still the old Wanamaker's. In Philadelphia, traditions die hard. Wanamaker's helped give Philadelphia its identity, and it is good to know that you can still hear the world's largest pipe organ, see the famous Light Show at Christmastime and meet the rest of Philadelphia at the Eagle.

Starting a New Business

John Wanamaker was the epitome of a great business man who understood civic responsibilities.
—Governor Ed Rendell, former mayor of Philadelphia, 1991–1999

Apparently John Wanamaker was a very nice and very broad-minded man" states Louise Wanamaker. Her husband's great-grandfather changed the way America did its business. In the past, customers bargained with shop owners in order to obtain the best price. Only the shrewdest merchant and the savviest customer were ever truly satisfied with a sale. But that all changed when John Wanamaker opened his doors.

John Wanamaker was born in 1838 and grew up in the Greys Ferry neighborhood of South Philadelphia. He was the oldest of seven children, and his parents were devout Presbyterians. His parents reared John to be just as devout and loyal to the Presbyterian faith. At the age of fourteen, John left school and went to work as an errand boy. But two years later, he received his first taste of retail work when he took a job in a men's clothing store. When he was nineteen, Wanamaker changed direction and worked at the Philadelphia YMCA. He was appointed secretary and became the first full-time YMCA secretary in America. At the same time, he founded the Bethany Sunday School on South Street. Wanamaker was passionate about his work, and in time Bethany became the largest Sunday school in America. While at Bethany, he met Mary Brown. Mary was a student at Bethany, and, in 1860, the two were married.

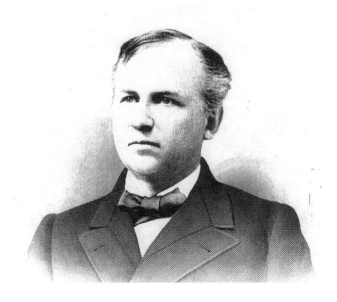

An early image
of a young John
Wanamaker. *Courtesy
of the author.*

Wanamaker enjoyed his work at the YMCA but he still craved his own business. Torn between his religious activities and the new world of commerce, he turned his attention toward commerce. Wanamaker partnered with his brother-in-law, Nathan Brown, and established a men's and boys' store named Oak Hall—Wanamaker & Brown. The store, located at Sixth and Market Streets, opened on April 8, 1861, just three days before the start of the Civil War. It might not have been the best time to start a business, so Wanamaker and Brown relied on unorthodox means to promote their business. The day before the doors opened, Wanamaker posted signs and banners throughout Philadelphia that simply said "W&B."[1] People did not know what the initials stood for and they sought out their meaning. The few customers that showed up on that first day quickly grew in number, and it is clear that the modern age of retail advertising began with those simple W&B signs.

Wanamaker & Brown took in $24.67 on their first day of business. John continued to believe in the power of advertising. He spent his first $24.00 on newspaper advertisements and kept the remaining $0.67 for change. Wanamaker & Brown used billboards and balloons to promote the store. A healthy combination of revolutionary advertising and strong customer service turned Oak Hall—Wanamaker & Brown into a very successful business. With the Civil War progressing, Wanamaker & Brown was able to grow its new organization. The two businessmen successfully received contracts to produce military uniforms and local city officials' garments.

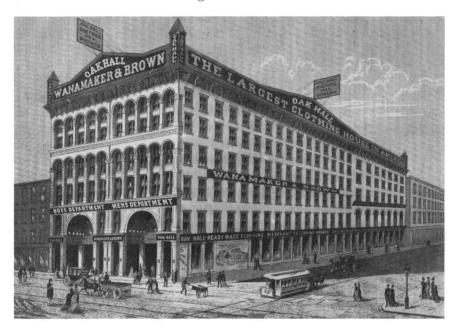

An image of the original Oak Hall, Wanamaker & Brown men's clothing store at Sixth and Market Streets. *Courtesy of the Historical Society of Pennsylvania.*

In 1865, Wanamaker revolutionized retailing by offering money back if a customer was dissatisfied with his or her purchase. This policy was just unheard of at the time. Wanamaker even boldly advertised "those who are not pleased with what they buy, do us a positive favor to return the goods and get the money back." He was eager to build customer satisfaction, and he hoped that his goods and services would not fail to "please the folks at home." In addition to this new form of reciprocity, Wanamaker began marking the prices on his goods. He disliked bargaining. Wanamaker believed that bargaining resulted in harm to both the customer and the merchant.[2] This one-price policy was revolutionary at the time but it soon became the accepted method for conducting retail business.

Nathan Brown passed away in November 1868, granting Wanamaker sole control of the operation. In April 1869, he opened a second, more exclusive store near the intersection of Ninth and Chestnut Streets. Business continued to grow at both stores, and, by 1871, Wanamaker & Brown was the largest men's store in the country.[3] By 1871, sales at the two Wanamaker stores exceeded $2 million a year. Wanamaker became the first American retailer to travel overseas to buy merchandise, and he especially loved

traveling to England. He purchased items for his "everyone's the best" customers because the British goods were "the best money could buy."[4] Both of his stores carried men's clothing exclusively but his travels abroad opened Wanamaker's eyes to all the possibilities of unique merchandise offerings. In 1874, he made the bold decision to buy the large, abandoned Pennsylvania Railroad freight station at Thirteenth and Market Streets. A new era of Philadelphia retailing was born.

A New Kind of Store

John Wanamaker didn't follow trends; he created them.
—*Jane Von Bergen, columnist,* Philadelphia Inquirer[5]

On March 20, 1876, the old Pennsylvania Railroad freight depot became Wanamaker's newest store, which he proudly named the Grand Depot. Philadelphia was in the midst of celebrating the Centennial Exposition, and thousands of visitors were drawn to see the nation's largest men's and children's clothing store.

In his advertisements, Wanamaker stated:

> *There is no store in the United States that covers so much ground floor as our single establishment at Thirteenth and Market, and such a busy scene as it presents, is well worth going a long distance to see. Some of our employees are especially detailed to show visitors around who wish only to look, not to buy.*[6]

Not only did the Grand Depot include special amenities like sitting rooms for weary shoppers, the store also operated a restaurant for hungry customers. It was the first time that any store in the country offered such a service. The centerpiece of the store was a ninety foot circular counter that featured the latest in ladies' silks. The store was just as much a tourist attraction as the exposition itself as visitors had never seen such a large retail operation before.

Though his store was a huge triumph, Wanamaker wanted to expand his operation to include more than just men's and children's clothing.

Wanamaker's Grand Depot, located at Thirteenth and Market Streets. *Courtesy of the author.*

After a successful first Christmas season, the Grand Depot closed its doors for a complete transformation. Wanamaker wanted to sell all types of merchandise, especially the unique goods that he had seen on his buying trips. He planned to increase the size of the Grand Depot and open what he called a "New Kind of Store."

For some reason, Wanamaker disliked the term "department store." He preferred calling it a "composite store." No matter what it was called, 71,106 people showed up to its grand opening on March 12, 1877. After catering exclusively to the male customer for almost sixteen years, the store now appealed to the average female shopper. The store housed sixteen different departments and carried everything from ready-made clothing to furniture. In one of his signature advertisements, Wanamaker stated, "ladies will come from far and near to purchase their dry goods and wearing apparel of every description."[7]

Perhaps most importantly, Wanamaker advertised his store as the "Stewart's of Philadelphia."[8] If any business ever fit the bill as America's first department store, it was New York's A.T. Stewart & Co. Alexander Turney Stewart was John Wanamaker's hero. Stewart opened his first store in 1846 and soon incorporated many of the same business philosophies that Wanamaker admired and eventually adopted, including a no-bargaining policy. Stewart's also offered low prices, possible because of the store's high

sales volume. In 1862, Stewart opened his Iron Palace, a grand emporium that covered an entire city block. Most importantly, Stewart departmentalized his store as this large building soon housed over thirty separate departments.

Not only was Stewart a true Merchant Prince, he was also an Evangelical Protestant. "Wanamaker admired Stewart", says Temple University professor Herbert Ershkowitz. "Stewart was the founder of the original department store and Stewart was his idol." Wanamaker was eager to achieve the same type of reputation in Philadelphia that Stewart had in New York. Stewart was one of the richest men in New York and soon Wanamaker was one of the richest men in Philadelphia. With money came power and some people in Philadelphia were concerned that Wanamaker was too powerful. Some merchants berated Wanamaker's ability to sell his merchandise at such low prices. He did so only because he tended to buy his goods directly from manufacturers.

Regardless what people thought of him, Wanamaker continued to make history with his new store. In January 1878, he introduced the first annual White Sale. This sale was an attempt to sell excess stock in bedding during a traditionally slow time of the year. He chose the name White Sale since all linens were exclusively sold in white. Later that year, Wanamaker visited Thomas Edison's Menlo Park Laboratory. By Christmas 1878, Wanamaker's was the first store in the world to be lighted by electricity. When the store was first lit, crowds cowered a half-block away from the store, afraid the building would blow up.[9] In 1879, Wanamaker's housed the first telephone in a store, and, in 1880, the store introduced the pneumatic tube system. Wanamaker introduced a fine art gallery in 1881, elevators in 1882 and a mail-order system in 1883. By 1885, the merchant pioneer was operating three stores with over four thousand employees. John Wanamaker decided to concentrate all his energy on the Grand Depot and renamed the store John Wanamaker. He sold the controlling interest in his other two stores to his brothers William and Samuel.[10] These stores were renamed Wm. H. Wanamaker and S.N. Wanamaker & Co. The Wm. H. Wanamaker stores continued to be a leading menswear retailer until late in the twentieth century.

As the success of his store grew, so did Wanamaker's political aspirations. He became deeply involved in the Republican Party. However, it was hard for Wanamaker to separate his political life from his religious life. Professor Herbert Ershkowitz states, "His campaigns for office were often moral crusades in which he branded his opponents as personifications of evil." Though he felt he was taking a high moral ground, Wanamaker lost political support. This led to unsuccessful bids for senator and governor.

Using his business connections, Wanamaker helped raise vast amounts of money for Benjamin Harrison's candidacy for president. After Harrison's victory in 1888, Wanamaker was appointed postmaster general. During his tenure, he pushed for many reforms to the post office department. His proposals included the introduction of parcel post and rural free delivery. In addition, he advocated for controls of the nation's telephone and telegraph systems. Even though these changes were not implemented until after his term ended, Wanamaker received criticism from business and political competitors who saw his position on Harrison's cabinet as a conflict of interest.

As John got older and his interests became broader, he was anxious to teach his children how to run the business. John's oldest son, Tom, began to assume operating control by the 1890s. However, his son Rodman was not as interested. He had spent time working in the store in previous years but he did not want to stay in Philadelphia. In 1886, Rodman left Philadelphia and moved to Paris. This move helped Rodman satisfy his love of fine art while he continued to work for the store as head of the Paris buying office.

Wanamaker's hero, A.T. Stewart, passed away in 1876, and his historic New York store fell into the hands of mismanagement. Wanamaker had always given Stewart credit for his business success. In return, Stewart had publicly stated "Wanamaker was going to become America's most successful merchant." By the 1890s, Stewart's operated as Hilton, Hughes & Co. When that store went into receivership in August 1896, Wanamaker came to the rescue.

NEW YORK, NEW YORK

In Philadelphia, Wanamaker was the King. And he felt that if he could make it in New York, he could make it anywhere.
—Herbert Ershkowitz, professor, Temple University

On September 29, 1896, John Wanamaker assumed control of New York's landmark A.T. Stewart store at Broadway and Ninth Streets. The purchase price was rumored to be around $2 million. He was now the head of his hero and mentor's business. With the acquisition of the Stewart store, Wanamaker was anxious to bring his level of merchandising expertise to New York and to hopefully become a nationally recognized merchant pioneer. He felt he could bring something different to New York City. On November 17, 1896, the New York Wanamaker store officially opened. The company promised that it would "simply keep a good Wanamaker store with no startling innovations." Wanamaker wanted to replicate the success of the Philadelphia store in New York, so he had his department heads spend three days in Philadelphia and three days in New York until the business became "thoroughly systematized." Rodman was called home from Paris and put in charge of the New York store.

Also in 1896, Wanamaker inaugurated the John Wanamaker Commercial Institute. Cadets came to both the Philadelphia and New York stores to attend classes and to learn the retail trade. In addition, they played in bands and sang in choirs. Ray Biswanger, head of the Friends of the Wanamaker Organ, felt that Wanamaker had other intentions for these Cadets. "John Wanamaker would use every holiday to have a public ceremony, and he

would use these kids [in the ceremonies]. It was for the benefit of tourism. This helped make Wanamaker's different," stated Biswanger. Being a Wanamaker Cadet was also a symbol of prestige for young men and women in Philadelphia and New York.

Former Drexel University professor Mercia Grassi remembered her aunt telling stories about Wanamaker's program.

> *My aunt became a member of Wanamakers' Cadet Corps right after World War I. Wanamaker picked the most elegant ladies of Philadelphia. He trained the ladies and sent them to be the sales associates at the aisle-end counters that faced the motor entrance where all of the pizzazzy men of Philadelphia came in to go to lunch. The object was to attract these men through these very elegant ladies so that they would want to buy for their families.*

Every summer, the Cadets spent two weeks at a camp in Island Heights, New Jersey. In addition to recreational activities, the Cadets engaged in a military-style training program. Many young men graduated from the John Wanamaker Commercial Institute and became prominent citizens of Philadelphia and New York.

Unlike the Philadelphia operation, the New York Wanamaker store faced an uphill battle. An early Wanamaker publication stated "The first year's progress was difficult because an entirely new organization had to be made and perfected."[11] Unable to gain a loyal following even from the beginning, the new store was considered too far downtown to effectively compete with stores such as Gimbels and Macy's.

Gimbels's new store on Herald Square offered extremely competitive prices and enjoyed the resulting strong sales.[12]

Wanamaker felt the competition from Gimbel Brothers in Philadelphia as well. Gimbels's new store on Market Street made Wanamakers' renovated depot look worn. Wanamaker worried about the safety of his Philadelphia store, wondering if it had the potential to become a firetrap. Wanamaker wanted to replace the Philadelphia store building and he wanted to add on to the New York store. He bought property around the Philadelphia site, thus eliminating any nearby competition. In 1902, Wanamaker met with famed Chicago architect, Daniel Burnham. Burnham's legacy includes Chicago's Marshall Field and Boston's Filene stores. Burnham was eventually engaged to design both new stores for Wanamaker. It was decided that the Philadelphia store would be rebuilt in three stages so that the store could continue to conduct business during its renovation.

Right: The Wanamaker's Stores at Broadway and Eighth Street in New York City. The former A.T. Stewart building is in the foreground. *Courtesy of the author*.

Below: A view of the Market Street side of the Grand Depot in Philadelphia from 1902. City Hall is in the background. *Courtesy of PhillyHistory.org, a project of the Philadelphia Department of Records*.

A matchbook image of the Bridge of Progress that connected the two Wanamaker's stores. *Courtesy of the author.*

Burnham designed a grand addition to the New York store. The two buildings were to be connected by a Bridge of Progress. Problems with finances and zoning permits caused lengthy construction delays for the two construction projects. However, John Wanamaker New York opened with great fanfare on October 1, 1907, two years after its original projected date of completion. Over 200,000 people visited Wanamaker's during its first three days. In addition to the new modern addition, the former A.T. Stewart store now featured a magnificent rotunda and staircase. This newly completed structure contained thirty-two acres of floor space and employed 6,000 workers. John's son, Rodman, helped outfit the store with works of art. A Wanamaker publication proudly announced that the new addition contained "eight spacious floors loaded with the best makes of reliable merchandise selected especially for New York sales."[13]

In spite of the initial success of the New York opening, John Wanamaker entered a very critical time. In February 1907, Wanamaker's "magnificent summer residence," Lindenhurst, was destroyed in a massive fire. Lindenhurst was filled with some of Wanamaker's most prized pieces of art. As the building burned, firemen and neighbors tried desperately to save many of

the priceless artifacts. Over eight hundred pieces of art were quickly removed from the burning structure. Some paintings were cut from their frames. The fire attracted many spectators and unfortunately many of the paintings were hastily thrown into the snow and trampled on by those watching the flames.[14] The fire at Lindenhurst destroyed many of Wanamaker's prized antiques and tapestries. Also destroyed in the fire was a sentimental gift that John had given to his son Rodman—a small pipe organ.

The Philadelphia store was only half built when the financial panic of 1907 hit. In March 1908, John lost his oldest son, Tom. He relied on his son, Rodman, to see him through this hard time. Rodman, who was in charge of the New York store, was summoned to Philadelphia. The panic hurt sales at both stores. Construction delays continued at the Philadelphia store, as some bills went unpaid. But John and Rodman were able to weather the financial storm and the two Wanamakers soon opened one of America's greatest department store buildings.

The Eagle Has Landed

I remember going into the Philadelphia store for the first time and just feeling "Wow, this is where it started." Everybody kept saying that "everybody meets at the Eagle" and I thought "isn't that cool?"
—*Pat Ciarrocchi, news anchor, KYW-TV*

After almost ten years of construction, John Wanamaker opened his new Philadelphia store in the summer of 1911. The opening of the impressive structure was the perfect way to celebrate the company's fiftieth anniversary. The store was built in three sections. In April 1904, work began on the first section at Market and Juniper Streets. The final section to be completed was along Chestnut Street. But it was the second section of the construction that captured people's attention and inspiration. The center of the store contained a Grand Court that soared six stories in the air.

The store's famous architect, Daniel Burnham, was proud of his new building. "The building as a whole, both inside and outside, is the most monumental commercial structure erected anywhere in the world," said Burnham.[15] Its granite exterior and marble interior contained 1,019,854 square feet of selling area. The new Wanamaker store was spread over fourteen floors, ten of which were devoted to selling space. Back in 1902, Wanamaker had instructed Burnham that the store should be "simple, unpretentious, noble, classic—a work of art and, humanly speaking a monument for all time."

On December 30, 1911, Wanamaker's became the first retail store to be dedicated by an American president. Wanamaker had remained faithful and

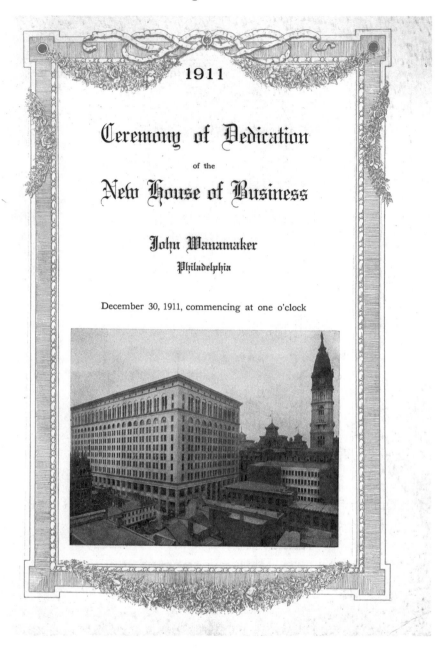

The official program cover for the dedication of the new Wanamaker's store in Philadelphia. *Courtesy of the author.*

active in the Republican Party and supported William Howard Taft with his bid for the presidency. Taft returned the favor. He came to Philadelphia where he congratulated Wanamaker on his success.

Taft addressed the crowd and said:

> *I congratulate Mr. Wanamaker that he has been spared in his long and active life until this moment, when he can look around and see, in all its inspiring whole this enduring monument to the clear-sightedness and genius of his business career.*

Taft also praised the burgeoning department store industry as "one of the most important instrumentalities in modern life for the promotion of comfort among people." After dedicating the store, he visited a local newspaper and Independence Hall, where he rang the Liberty Bell by using his knuckles.

In the middle of the Grand Court stood a 2,500-pound bronze eagle that had been on display at the 1904 St. Louis Exposition. Wanamaker purchased the eagle for $10,000. The floor of the Grand Court was reinforced with a special girder in order to prevent sagging. The eagle contained 6,600 bronze feathers, each one hand-assembled by craftsmen employed from Frankfort, Germany. It wasn't long before the Wanamaker Eagle became one of the country's most famous trysting places.[16]

With the introduction of the Eagle at the Philadelphia store, every subsequent Wanamaker store always had a large sculpture of an eagle to call its own. Not only was it a symbol of Wanamaker's, the Eagle also became part of Philadelphia's identity. But the Eagle was not the only souvenir that Wanamaker purchased from the St. Louis Exposition. Perhaps the greatest piece of art in Philadelphia was installed right in his own Grand Court.

Organ Donor

The Wanamaker organ is battleship rugged and meant to last throughout the ages.
—*Ray Biswanger, president, Friends of the Wanamaker Organ*

As the Grand Court construction neared completion, Rodman Wanamaker was determined to make this amazing interior space as impressive as possible. Rodman's passion for the arts strengthened after his ten-year stay in Paris. His knowledge of fine art helped the Wanamaker family win acceptance in social circles not just in Philadelphia but also in New York. He was determined to fill the Grand Court with music. Rodman declared, "I want the finest organ in the world built up there above that gallery."

After realizing it would take too long to design and build such an organ, Rodman went in search of one. He learned that the Louisiana Purchase Exposition organ from the 1904 St. Louis World's Fair might be available. Wanamaker sent George Till, an organ technician, to St. Louis to see if the organ fit the specifications of size and sound that Rodman hoped to fill the Grand Court with. Till was satisfied, and Wanamaker reportedly purchased the organ for "next to nothing." In the summer of 1909, the exposition organ was loaded onto thirteen railroad freight cars and was transported to Philadelphia.

The organ was designed by George Ashdown Audsley and built by the Los Angeles Art Organ Company. "The Los Angeles Art Organ Co. took their name very seriously as their organs were meant to be works of art. They only used the best materials," says Ray Biswanger, president of the Friends of the Wanamaker Organ. When the organ was finally finished for the fair, it contained 10,059 pipes and 140 stops. The famous French organist

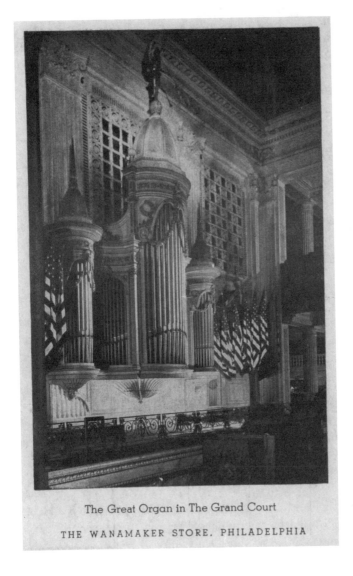

The Great Organ in The Grand Court

THE WANAMAKER STORE, PHILADELPHIA

A souvenir postcard of the Wanamaker organ. *Courtesy of the author.*

Felix-Alexandre Guilmant performed a series of recitals on the instrument as part of the fair's highly touted presentations. These performances marked Guilmant's final American appearances, and Guilmant praised the quality of the organ.[17] If the organ was good enough for Guilmant, it certainly was good enough for the Wanamakers.

It took almost two years to properly install the organ in the Grand Court and the instrument made its first public appearance on June 22, 1911. Unfortunately, Rodman felt that the instrument's sound did not fill the

space as greatly as he had hoped. He was determined to make the organ bigger, better and stronger. Rodman established an organ shop on the new building's twelfth floor, and, by 1914, eight thousand pipes were added to the instrument. Students from the John Wanamaker Commercial Institute also began to learn the organ-building trade. "The JWCI students were one of the reasons that John wanted the organ," says Biswanger.

The Great Organ was respected and praised by music lovers worldwide. On March 27, 1919, fifteen thousand people gathered in the Grand Court to hear organist Charles M. Courboin and Leopold Stokowski with the Philadelphia Orchestra perform Charles Marie Widor's Sixth Symphony for organ and orchestra.[18] Courboin returned the following year to perform a series of evening recitals and also joined Stokowski and the Philadelphia Orchestra for a performance of Symphony no. 3, or Organ Symphony, by Camille Saint Saëns. The specifics of the organ were quite impressive.

A John Wanamaker promotional brochure on the Great Organ states:

> All the guest artists have been impressed by the beauty, completeness, and accessibility of the console. Weighing nearly two and one-half tons, it is mounted on a platform at the east side of the court on the first floor above the main floor. It rests on a pivot and track and can be turned at will. Everything is within the organist's reach. It has six manuals with 451 stops and 964 controls. There are 42 accessories for the feet and 729 tilting tables operated by remote control from 168 pistons under manual keys, of which there are 46 masters and 46 reversibles.

The organ used massive amounts of electricity to operate. According to legend, whenever the power to the organ was turned on, someone had to call Philadelphia Electric to request more energy. That story was an old wives' tale but it has been said that if all eight blowers of the organ were turned on at once, it could blow every fuse in the entire building. The organ was also rarely played for more than an hour in order to prevent overheating that could damage the wind chests.[19]

Since the Wanamaker building opened in 1911, there has always been a full-time organist. The first Grand Court organist was Dr. Irvin J. Morgan, who presided over the store's dedication ceremony with President Taft. Though he was praised for his musical abilities, Morgan battled alcoholism that hampered his ability to "get around the controls" at times.[20] In 1917, Mary E. Vogt took over as the store's organist. Mary began working at the store when she was twelve years old. She was thirty-two when she was

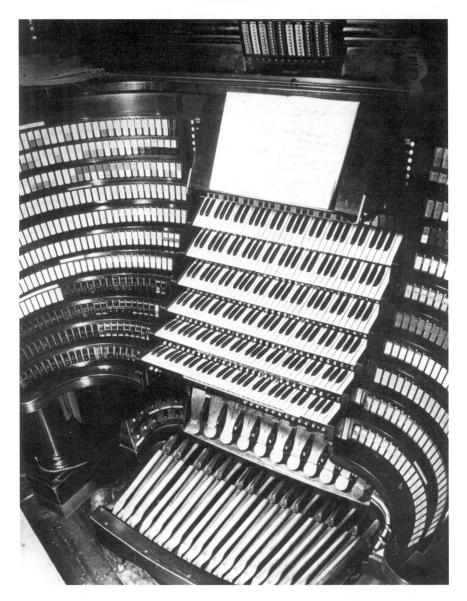

A view of the new console of the Wanamaker organ. *Courtesy of the author.*

handpicked by Rodman to become the store's next full-time organist. She was never formally trained in music but, nonetheless, she was a fixture at Wanamaker's, and Rodman looked to her for musical advice. Louise Wanamaker knew Mary Vogt well and would often visit her at the console. "I used to go in the organ loft when she was playing and talk to her about

a new hat or something equally important," says Wanamaker. Mary held the position for forty-nine years, retiring in 1966. "She stayed on a little too long," says Ray Biswanger. Dr. Keith R. Chapman replaced Mary Vogt and remained until his untimely death in 1989. Chapman was viewed as a consummate musician with a warm personality.

Ray Biswanger of the Friends of the Wanamaker organ recalls one visit with Chapman in the 1970s.

> *I remember I was visiting Keith Chapman and I was sitting in the loft. All of the sudden, I saw a kid running through the court. He was being chased by a whistle-blowing policeman. Keith stopped what he was playing and broke into this great* Keystone Cops *music.*[21]

The acclaimed organist, Peter Richard Conte, became Grand Court organist after Chapman passed away. Conte was an assistant of Chapman's and praised the organ for its "symphonic" beauty.

At its completion in 1930, the organ had 461 ranks and 28,482 pipes. But like most pipe organs, the pipes that are seen from the Grand Court are façade pipes and are strictly ornamental. The Great Organ was touted as the world's largest pipe organ. Its closest competition was the organ located in Boardwalk Hall in Atlantic City. Of the two massive instruments, the Wanamaker organ was the most popular.

The Philadelphia Wanamaker store was not just home to the Great Organ in the Grand Court. Two additional organs were located within the store. The Greek Hall, an area for respite for Wanamaker shoppers on the store's second floor, housed a small, fifteen-rank pipe organ. Before his death, Rodman donated the Greek Hall instrument to a retirement home. By the early 1930s, it was replaced by a "famous Hammond pipeless electric organ."[22] The Egyptian Hall, where the store's piano department was located, contained a sixty-rank pipe organ. By the late 1930s, the Egyptian Hall organ was decommissioned and the instrument was broken up for parts.[23]

The presence of an organ was not limited solely to the Philadelphia Wanamaker store. The New York store was home to the Wanamaker Auditorium Organ. A 1,500-seat auditorium was located on the third floor of the newer building of the New York Wanamaker complex. The organ was built in 1904 by the Austin Organ Company of Hartford, Connecticut. Damaged by a fire in 1917, the Wanamaker Organ Shop rebuilt the instrument in 1920. It was enlarged to include 4 manuals, 115 stops, 118

ranks and 7,422 pipes.[24] The New York Auditorium Organ served a different purpose than the Great Organ in Philadelphia. The New York Auditorium was a formal setting where shoppers could take a break from shopping and sit and relax to the music. Rodman was never fully satisfied with the sound of the New York organ. Over the years, the organ became less important to the New York store. Water, created by the air-conditioning system, leaked into the organ and damaged the instrument. "Build an organ and water will follow," says Ray Biswanger.[25] In August 1945, Wanamakers announced that its New York Auditorium would be divided into three television studios for the DuMont Television Network.[26] Consequently, the New York Wanamaker Auditorium Organ fell silent.

On the other hand, the Great Organ continues to be heard twice daily in the Philadelphia Wanamaker building. Thousands of customers, like former KYW-TV reporter Trudy Haynes, enjoyed shopping at Wanamakers and the organ was part of the experience. "I always enjoyed the organ, the music and the feeling of elegance when you went into Wanamakers," says Haynes.

Organ curator Curt Mangel praises the genius of the organ's console layout, which was designed by an organ builder. He says, "[The Wanamaker Organ] is without question the most famous organ in the world. It is the finest symphonic instrument ever built. It was built to imitate a symphony orchestra."

Every day, the Wanamaker store was filled with beautiful music. Every day, crowds gathered in the Grand Court to hear one of the world's finest musical instruments. And every day, shoppers and workers alike would await the sound of *Taps* over the store's loud speaker system, signaling the end of another day's business.

FAMILY TRUST

*After reading his papers, I became impressed with him as a person and that is what I
think is the explanation for his success. You have to excuse me as a Minister but I think
that his deep personal religious faith was the basis for his personality.*
— *William Zulker, Wanamaker historian*

After the rebuilding and reopening of the Philadelphia store, Wanamaker
was able to concentrate on many of his other interests. He devoted
more time to his church and he also devoted more energy to the Republican
Party. In 1915, Wanamaker stunned the political world by suggesting the
United States buy Belgium from Germany for $100 billion, setting it free.
Wanamaker urged the United States to be neutral during World War I, but
his proposition concerning Belgium did nothing more than earn ridicule.

In 1916, Wanamaker opened the Down Stairs Store. The store was not
conceived to be a bargain basement of the main store. It was a place where
"Philadelphia could buy dependable merchandise of true Wanamaker
quality at the lowest possible prices."[27] The Down Stairs Store was also
home to the Dairy, Wanamaker's famous luncheon spot.

Wanamaker continued to attract attention with his stores and he
continued to lead the way with innovative marketing. Wanamaker believed
in the power of advertising and his groundbreaking promotions featured
his catchy slogans and Wanagrams.[28] He believed that "you can not afford
not to advertise." It was John Wanamaker who coined the phrase the
Customer Is Always Right. He was the first merchant to purchase full-page
advertisements in a newspaper. John felt that the key to keeping prices lower

Left: A matchbook cover from Wanamaker's famous Dairy restaurant. *Courtesy of the author.*

Below: A scene of the Grand Court from Christmas 1920. *Courtesy of the Historical Society of Pennsylvania.*

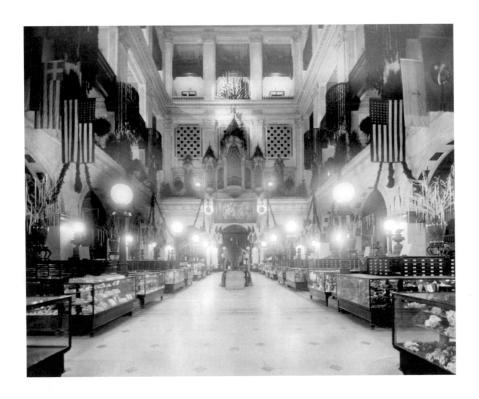

was to entice as many customers as possible into the store. Even when retail prices typically rose after World War I ended, Wanamaker merchandise was reduced 20 percent.

On December 12, 1922, the cities of Philadelphia and New York were stunned to learn that John Wanamaker had died early that morning from a heart attack. He was eighty-four years old and had been ill with a "heavy cold." He passed away in his house at 2032 Walnut Street with all of his family at his bedside, except Rodman. Rodman, also ill at the time, was in New York and quickly made his way to Philadelphia. Word of John's death reached the stores after the doors had already opened and "management went floor to floor announcing to the employees that Mr. Wanamaker is dead." The stores closed and heavy black draping covered the windows.[29]

John Wanamaker's funeral was held on December 14, and all of Philadelphia mourned the loss of its most famous citizen; all Philadelphia public schools were closed. When the funeral service began at 2:00 p.m., the Philadelphia Stock Exchange was halted and competing merchants had their employees and customers "stand in deep silence" for five minutes. The *New York Times*'s obituary stated that John's success was due to "thinking, trying, toiling and trusting in God."[30]

On Thanksgiving Day 1923, the Cadets of the John Wanamaker Commercial Institute joined the mayor and ten thousand Philadelphians at City Hall to unveil a statue honoring John Wanamaker. It read simply "John Wanamaker—Citizen." Leopold Stokowski led the Philadelphia Police Band as part of the celebration.[31]

Rodman had been groomed to lead the Wanamaker business. He was well-educated, widely traveled and had good business sense. But Rodman did not do anything without his father's approval. "John listened to what Rodman had to say but Rodman didn't lift a finger without the approval of John," says historian William Zulker. Upon John's death, Rodman took charge of the stores and planned one more great honor for his father. Rodman wanted to place the largest bell in the western hemisphere on top of the Philadelphia store. Rodman sent organist Mary Vogt to England to test the different tones of certain bell makers.[32] Rodman wanted the bell to be in place on July 4, 1926, the nation's 150th anniversary. Unfortunately the deadline passed. Instead, Rodman settled for the bell to be rung on New Year's Day 1927. The Founder's Bell, the tenth largest bell in the world, weighed seventeen tons and its "tonal purity" could be heard for thirty miles. Once the bell was hoisted to the building's roof, it was placed in a belfry one hundred feet above the store. When Rodman first rang the bell, he was disappointed that

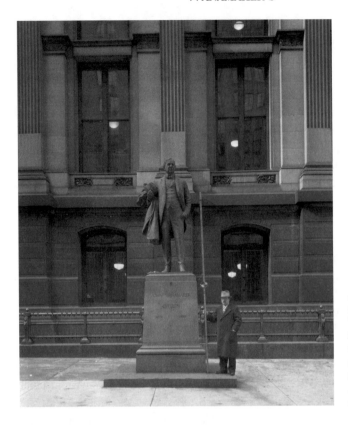

A 1936 photograph showing the John Wanamaker statue outside City Hall. *Courtesy of PhillyHistory. org, a project of the Philadelphia Department of Records.*

the city buildings dampened its resonance.[33] But even today, every hour on the hour, except Sundays and holidays, Philadelphians set their watches to Rodman's tribute to his father.

Rodman proved to be a successful merchant and the stores became even more profitable under his leadership. However, Rodman did not see the same enthusiasm for business in his children. "Rodman spoiled his children to the point that they couldn't manage anything. He had no choice but to put it [his money] into a trust," says Wanamaker family member Christopher Kellogg. Rodman's trust specified that control of the business be given to a management group when he died. This prevented his children or grandchildren from running the stores. These family members could not make any financial decisions that affected the operation of the store, although they became trustees and served on the board of the trust. Rodman's will stated that twenty-one years after the death of his last grandchild, the trust would be dissolved and the money would be distributed among the remaining family members.[34]

An "innovative" advertisement for the New York Wanamaker's store from the 1920s. At the time, advertisements always included words from the founder.
Courtesy of the author.

On March 9, 1928, Rodman passed away from kidney failure after a long cold. Citizens of Philadelphia and New York mourned his passing and praised his civic contributions. Control of the business was out of his family's hands and the store sailed into uncharted waters without a Wanamaker at the helm.

A FLAGSHIP ADRIFT

Wanamakers had the history of allowing people not to be solicited and hustled in order to make a sale. The store invited people to come in, browse, and just enjoy a walk around the store.
—*Christopher Kellogg, Wanamaker family member*

The Wanamaker family was not as interested in being merchants as they were interested in getting a good return on the business. They had seats on the Board of Trustees of the Rodman Wanamaker Trust and they received salaries for serving in this manner. "The family pushed them [the management of the store] to limit the expenditures that were required for the continuance or the further expansion of the business," says Wanamaker historian William Zulker.[35]

The Philadelphia Wanamaker's continued to dominate the Market Street business district. It was home to the Crystal Tea Room, Philadelphia's largest dining room. Known formally as the Great Crystal Tea Room, the restaurant could serve fourteen hundred guests at a time. It was modeled after the tearoom in the home of Robert Morris, a financier of the American Revolution. The Crystal Tea Room was famous for oak floors and oak columns in Circassian brown finish as well as its signature crystal chandeliers. This famous restaurant covered twenty-two thousand square feet on the store's eighth floor. It had the capacity to cook seventy-five turkeys at one time. Jan Whitaker, author of *Tea at the Blue Lantern Inn* and *Service & Style—How the American Department Store Fashioned the Middle Class* says, "a tea room in a department store was a place unlike the average restaurant. It had a degree of luxury but it was quiet, not showy."

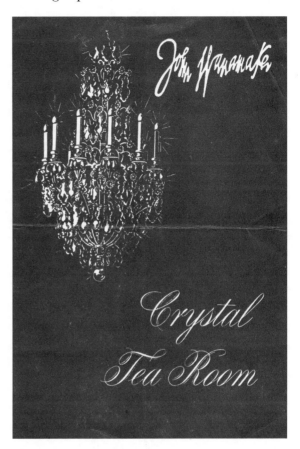

A menu cover from Wanamaker's famous Crystal Tea Room. *Courtesy of the author.*

In regard to the Wanamaker's Crystal Tea Room, Whitaker says:

From the day the Crystal Tea Room opened, its aim was to surround diners with comfort and first-rate quality of the sort enjoyed by the solid middle-class citizens of Philadelphia. Tables were set with French china, hand-hemmed damask napkins, and Colonial reproduction silverware. Crystal chandeliers lit the room brilliantly, no doubt in striking contrast to many customers' homes still using gaslight before World War I. A 1950 menu signals patrons' simple tastes. Still among the city's largest and best eating places even then, the tea room offered humble items alongside more elaborate dishes. Fans of the deluxe could order shrimp salad or lobster thermidor but there was also plain Swiss cheese sandwiches, gelatin salads, and stewed prunes, all served with elegance. Whether homely fare or not, meals in the Crystal Tea Room remained stamped in memory as special occasions.[36]

The Crystal Tea Room was not the only restaurant on the eighth floor of Wanamaker's. Adjoining the Crystal Tea Room was the moderately priced restaurant La Fontaine and the Men's Grille.

The Philadelphia store contained the Wanamaker's Tribout Shop. The shop "was purchased bodily in Paris by Rodman Wanamaker in 1924."[37] Located at 20 Rue des Pyramides in Paris, Tribout was an elegant salon that sold clothing for women and infants, men's furnishings and "golf goods." Promotional information referred to the Tribout Shop as "a shop whose like you may never again know." Its distinctive merchandise for women combined the offerings of leading French and American designers "all with the unmistakable Tribout individuality and superiority." The Philadelphia store was also home to the Coty "Paris" Salon. The Coty Salon was located on the Main floor on the Chestnut Street side of the building. Stocked with the Coty's signature beauty products, the salon was "dedicated to the women of Philadelphia and devoted to the arts of beauty and charm," according to a company pamphlet. In addition to the Tribout Shop and the Coty "Paris" Salon, the Camee Candy Shop, the Jewelers' and Silversmiths' Hall, the famous Morgan Apothecary and one of the world's largest bookstores were located right in the store's Grand Court. "The Philadelphia store was the forerunner to the modern-day mall. The store carried 'everything from everywhere for everybody.' The only two things that they did not sell were food and fuel," says Wanamaker historian William Zulker.[38]

During every Lenten season, Wanamaker's proudly displayed two of John and Rodman's most influential works of art. The two paintings are by Hungarian painter Michael de Munkácsy and date from 1882: *Christ Before Pilate* and *Christ on Calvary*. These two massive works of art were cut from their frames and saved during the Lindenhurst mansion fire of 1907. The Munkácsy paintings were exhibited in the Grand Court to provide artistic and spiritual inspiration to the Wanamaker customer.

Wanamaker's returned to its menswear heritage and opened a separate eight-story Men's Store in the Lincoln-Liberty Building located directly adjacent to the Main Store in September 1932. This store had been planned for years. Its merchandise included the most inexpensive lines of clothing for men to the most costly imported goods. Broad and Chestnut Street was the perfect address for this "climax of a dream" that helped bring London menswear sophistication to the American audience.

A promotional guide to the store proclaimed the following information about the new Men's Store:

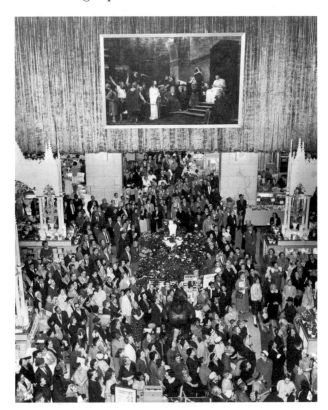

Crowds gather in the Grand Court to view the two Michael de Munkácsy paintings. Wanamaker's displayed the paintings during Lent as a means of giving spiritual inspiration to its customers. Seen here is Munkácsy's painting *Christ Before Pilate. Courtesy of Temple University Libraries, Urban Archives, Philadelphia, Pennsylvania.*

John Wanamaker himself selected the location during his lifetime in the belief that William Penn was right when he declared Broad and Chestnut Streets as "ye center of ye city." The opening of the store will mark one of the most powerful expressions of firm faith in the future of Philadelphia.[39]

The Founder's Bell was moved from its temporary home on the roof of the Wanamaker store to the top of the Lincoln-Liberty Building. The two Wanamaker buildings in Philadelphia secured Wanamaker's place as the premiere department store in the city.

The situation in New York was quite different. The New York store was "anything but prosperous." It was located far from the city's retail hub and its old-fashioned business techniques were seen as "too provincial" for the New York audience. What worked in Philadelphia did not always work in New York. The store was never truly successful. "[When he was alive] John Wanamaker knew that the New York store was a mistake but he put large amounts of money into it," says Professor Herbert Ershkowitz. Even

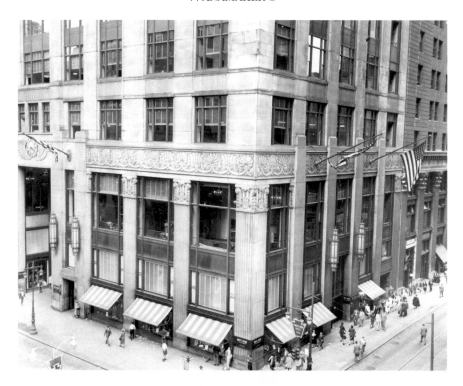

A bird's-eye view of Wanamaker's Men's Store in the Lincoln-Liberty Building. *Courtesy of Temple University Libraries, Urban Archives, Philadelphia, Pennsylvania.*

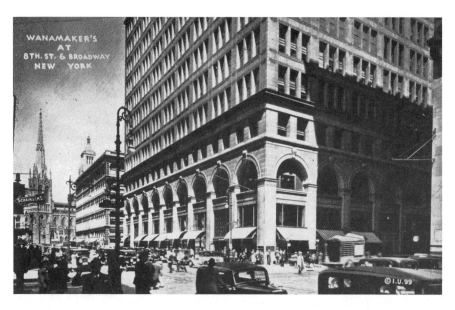

A postcard view of the New York Wanamaker's stores from the 1930s. *Courtesy of the author.*

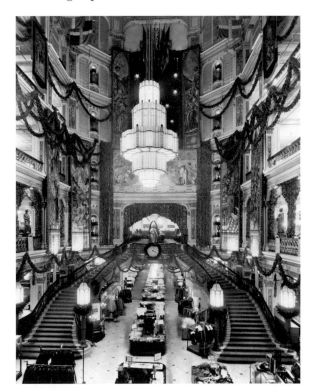

Right: A photograph of the ornate rotunda located in the former A.T. Stewart store from December 1930. *Courtesy of the Historical Society of Pennsylvania.*

Below: An interior view of the Wanamaker's new building from December 1931. *Courtesy of the Historical Society of Pennsylvania.*

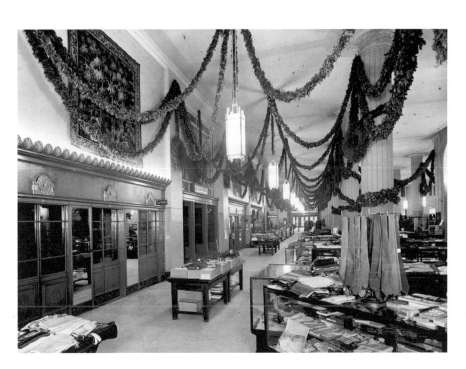

though the store was admired for its soft-spoken salespeople and its air of quiet gentility, many New York shoppers didn't feel it was worth their time to make a special trip to its off-the-beaten-path location at Broadway and Ninth Street.

In the mid-1930s, Wanamaker hired advertising legend Bernice Fitz-Gibbon to help draw people into the New York store. After a successful stint at Macy's, Fitz-Gibbon was shocked when she went to work at the New York Wanamaker's. She saw a store "with empty, cavernous aisles."[40] Because business had dropped off so significantly, the store had cut back drastically on its advertising budget. It was up to Fitz-Gibbon to find a way to "lure crowds into that lovely old deserted building too far downtown." With her gift of prose, Fitz-Gibbon transformed Wanamaker's advertising. Her soft-sell style of advertising had customers eager to once again step foot in Wanamaker's. When she advertised that the New York store restaurant served lemon pie that "trembles as it's placed on the table," customers flocked to the store to try the special lemon pie. When Fitz-Gibbon had no money to put on a fashion show, she brought in dancing instructors from Arthur Murray, dressed them up as models, and advertised the event as "Waltz me around again, Arthur." This revolutionary style of promotion began to draw crowds to the New York store but it also drew concern from the Board of Directors in Philadelphia.

In her book, *Macy's, Gimbels, and Me*, Fitz-Gibbon writes:

> *I had to spend too much time and energy struggling with the heavy hand of the heavy institution, Wanamaker's Philadelphia. The Philadelphia top brass resented my throwing out the "Sayings of the Founder," which had been displayed for decades across the top of every Wanamaker page. They were pontifical, boresome, musty, and fusty. I am certain that old John Wanamaker himself, if he had been around, would have tossed them out. It was he who said, "I am sure I could cut out half my advertising and save money. Trouble is, I don't know which half."*[41]

One of Fitz-Gibbon's greatest successes at the New York Wanamaker's was her promotion of the renovated Home Store. On March 31, 1937, Wanamaker's boldly advertised "11-1/2 hours of entertainment and instruction in the new Home Store." The new Home Store occupied four floors in the 1907 building, and Fitz-Gibbon brought musicians such as Guy Lombardo and Tommy Dorsey to serenade the crowds. Theater organist Hans Henke performed a recital on the store's new electric Orgatron, an electric organ "that sounds almost like a pipe organ." Sportsmen showed off

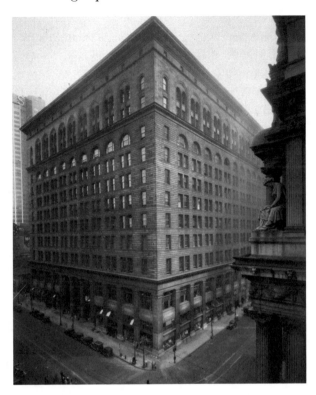

A stately view of the Philadelphia Wanamaker's store as seen from City Hall. The photograph was taken on September 5, 1932. *Courtesy of PhillyHistory.org, a project of the Philadelphia Department of Records.*

the latest techniques in marksmanship and badminton in the Wanamaker Country Club on the store's second floor. The celebration brought in hoards of shoppers and was all under the direction of Fitz-Gibbon. However, in 1940, frustrated with the Wanamaker leadership, Fitz-Gibbon left her job at Wanamaker's and went to work transforming Gimbels.

Wanamaker's missed some golden opportunities for expansion in New York City. In 1932, the Rockefellers gave Wanamaker's an opportunity to buy a city block just off of Rockefeller Center. This would finally give Wanamaker's the uptown presence that they so desperately needed. The board refused the offer. "They turned it down unfortunately and it was a big mistake," says Wanamaker family member Christopher Kellogg. Some people say that that decision was the biggest mistake the company ever made.

When Metropolitan Life was building in 1940 its mixed-use development in the Bronx called Parkchester, they had reserved space for a branch department store. Metropolitan Life was anxious to have Wanamaker's join the complex but Wanamaker's rejected the offer as they were still looking at "other possibilities that might present themselves." In 1944, Stevenson Newhall of the New York Board of Directors announced that the New York store had come to a

crossroads and "the store must decide whether it should stand still or expand." He cited the other lost opportunities and presented a plan: Wanamaker's would locate a seventy-thousand-square-foot store at Forty-seventh Street and Madison Avenue. The seven-story store would offer women's and infants' apparel and would provide "good taste, proper prices, courteous salesmanship and service" and "would not try to imitate all of the uptown shops."[42] The board debated the proposal for almost two years but then abandoned the idea. Another golden opportunity for Wanamaker's in New York was lost.

On November 29, 1946, Wanamaker's opened its Liberty Street store in New York City. The store was a miniature department store without home furnishings. The three-level building carried men's and women's clothing, cosmetics, accessories and china. "The store was successful and profitable because it was in a financial district which didn't have any stores," says Wanamaker family member Christopher Kellogg. The store had a receiving window that measured four feet square. If the merchandise couldn't fit through the window, the store didn't carry it.[43] The Liberty Street store proved to be Wanamaker's most successful business decision in New York City.

Back in Philadelphia, Wanamaker's continued to play the role of business and civic leader. In 1942, a War Bond Post opened right in the store's Grand

A scene of the empty Philadelphia store during a practice air raid drill. *Courtesy of Temple University Libraries, Urban Archives, Philadelphia, Pennsylvania.*

The Philadelphia store quickly reopens and fills with customers after an air raid drill. *Courtesy of Temple University Libraries, Urban Archives, Philadelphia, Pennsylvania.*

Court. When the post opened, city and state leaders gathered to show united support for the war and a rousing rendition of the *Star-Spangled Banner* was sung with the accompaniment of the famous Wanamaker organ.[44] However, absent from the ceremony was the Cadet Corps of the John Wanamaker Commercial Institute. Wanamaker's abandoned the institute in 1941, citing advances in public education that made the program unnecessary. In 1942, Wanamaker's launched a Tin Can Campaign that promoted "an arsenal in their own kitchen" for Philadelphia housewives. Advertisements educated housewives how to prepare used cans for salvage. "Because the Japs control 92 percent of the world's supply of new tin, housewives are informed, every ounce of tin now in the country must be reclaimed and re-used," said one Wanamaker's advertisement.[45] The company contributed annually to the United War Chest Victory Campaign, donating $65,000 in 1946 alone.

Wanamaker's was content with its business in Philadelphia. Through its art displays, musical presentations, rose shows and merchandise offerings that were geared toward any budget, the store was stable and successful. But Wanamaker's couldn't just sit back. There were many other large Philadelphia retailers that were all too ready to take a piece of the Wanamaker's market share.

OFF TO MARKET

Department store families were real citizens. They were extremely generous, very public spirited, and extremely influential in government.
—Lynne Abraham, former Philadelphia district attorney

Market Street was Philadelphia's commercial artery—at least as far as department store shopping was concerned. The street was home to six department stores, three of them located at the intersection of Eighth and Market Streets. In 1927, Philadelphia's six department stores registered one quarter of the entire retail trade from the nearly two million residents. Each store targeted its specific customer and each store earned its place in the city's economic and social culture.

STRAWBRIDGE & CLOTHIER

Anchoring the eastern end of the Market Street district was Strawbridge & Clothier. Justice C. Strawbridge and Isaac H. Clothier established their dry-goods business in 1868 on the northwest corner of Market and Eighth Streets. Both merchants were Quakers, and both merchants built the business on strong Quaker values and strong customer service. By the late 1800s, Strawbridge & Clothier expanded its offerings to include gowns and furs from Paris and Berlin, clothing for men and boys, bicycles, candies and china. The store rivaled Wanamaker's as the most complete store in

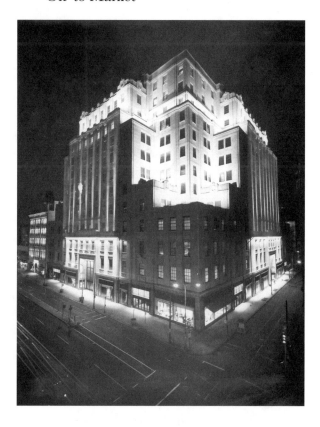

In 1968, Strawbridge & Clothier added accent lights to its Market Street flagship store. *Courtesy of Temple University Libraries, Urban Archives, Philadelphia, Pennsylvania.*

Philadelphia. Store officials saw that "the current tendency of shoppers was to seek the still greater convenience of one stop."

Strawbridge & Clothier promoted their "cash only, one price" business that sold quality goods at a small percentage of profit. In March 1906, store management came up with "a good-luck day" for their customers. The merchandise was sold throughout the store at the lowest price of the year. People would hunt for the special merchandise that was spread everywhere in the store. The event was named Clover Day and this sale became a long-standing tradition for Philadelphia shoppers. In 1911, store manager Herbert Tily spoke to his employees about the store's mission of sincerity, courtesy and confidence. A design, depicting William Penn shaking the hand of a Leni-Lenape Indian chief under an elm tree, was commissioned. This Seal of Confidence was the symbol of Strawbridge & Clothier's pledge to offer guaranteed merchandise and superior service in every business transaction. The Seal of Confidence was proudly displayed throughout the store building and was also featured in the store's advertisements.

In May 1930, Strawbridge & Clothier opened the first branch of a Philadelphia department store outside the city limits in the Main Line suburb of Ardmore. The following year, the company opened a more opulent branch on Old York Road in Jenkintown. And in October 1932, the Market Street flagship store celebrated its newly completed reconstruction with a Dedication Sale. Additional early branch stores included Wilmington (1952), Cherry Hill (1962), Springfield (1964), Plymouth Meeting (1966) and Neshaminy (1968). "Strawbridge's was way ahead [of the competition] in terms of buying property," says Professor Mercia Grassi. "The Strawbridges were far ahead nationwide in terms of what the next trend would be." By the end of the 1990s, the store that was built on confidence and Quaker values grew to thirteen popular Philadelphia-area locations.

Strawbridge's was a friendly competitor to Wanamaker's. Both Wanamaker's and Strawbridge & Clothier stood for quality and tradition. Both stores appealed to the same customer and most customers were loyal to one store over the other. Some saw Strawbridge's as the "rich store." District Attorney Lynne Abraham recalls Strawbridge's as a "little snooty."[46] "It was a little more distant. It had a patrician air to it," says Abraham. Some saw Wanamaker's as the higher-end merchant.

Professor Mercia Grassi said:

> Wanamaker's was definitely over Strawbridge's. Strawbridge's was never a fashion store. It was a family owned store that was known for value and quality. Wanamaker's was the upscale, fashion merchant.[47]

GIMBELS

Adam Gimbel didn't begin his business in Philadelphia; he began it in Vincennes, Indiana, in 1842. In 1870, his sons opened stores in Bloomington, Illinois, and Danville, Illinois, and eventually opened "the largest store ever" in Milwaukee in 1887. It wasn't until 1894 that they established a large store on the corner of Ninth and Market Streets in Philadelphia. The New York operation opened in 1910. Adam Gimbel referred to New York as the "toughest retail city in the world" and he was proud that the "toughest city" became a "Gimbel city." Though many people equate the name Gimbels with New York, shoppers in Philadelphia viewed their home as a "Gimbel city."

Gimbel shoppers in Philadelphia rode the world's first department store escalator in 1901. More importantly, Philadelphians thought

of Thanksgiving when they thought of Gimbels. In 1920, the store organized an employee band and fifteen cars to create the first Gimbels Thanksgiving Day Parade. This annual Philadelphia tradition consisted of floats, bands and balloons and ended its route right at Ninth and Market Street. Santa Claus would climb a fire truck ladder right into the window of Gimbels's Toy Department. "That way all of the children thought the *real* Santa Claus was at Gimbels," said former Philadelphia store manager Arthur C. Kaufmann.

In 1922, Gimbels became home to Philadelphia's first radio station, WIP. In 1923, the company purchased Horace Saks's New York store, and, in 1926, it purchased Pittsburgh's Kaufmann & Baer store. Additions to the

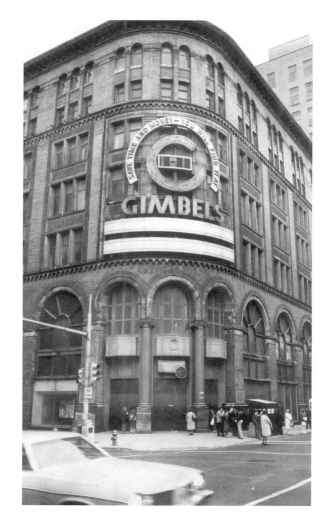

The original Center City Philadelphia Gimbels store, as it appeared in 1979. *Courtesy of Temple University Libraries, Urban Archives, Philadelphia, Pennsylvania.*

Philadelphia building in 1927 created the world's largest department store at that time. During World War II, Gimbels Philadelphia sold over $38 million in war bonds at its Freedom Window.

Gimbels catered to the middle-class Philadelphia customer. "It was a moderately priced store. You didn't expect to find anything unique at Gimbels," says Professor Mercia Grassi. But it still provided good competition for Wanamaker's and Strawbridge's. Gimbels, with large stores in Philadelphia, New York, Milwaukee and Pittsburgh, was able to buy merchandise in higher volume at lower cost than other department stores. This advantage made Gimbels a strong—and profitable—competitor.

In 1952, Gimbels opened a Saks Fifth Avenue store within its Center City Philadelphia location. This helped give Gimbels a more fashionable image. In February 1954, Gimbels opened the largest suburban department store branch in the Philadelphia area. It was in the northern suburb, Cheltenham. Gimbels's Upper Darby store opened in August 1957. Other locations included Great Northeast (1961), Moorestown (1964), King of Prussia (1966) and Lancaster (1970). Gimbels continued to grow in the Philadelphia market and it continued to fight its downscale image.

LIT BROTHERS

"Hats trimmed free of charge" was the motto at Lit Brothers. Lits' roots date to 1891 when two brothers and a sister opened a small dry-goods shop. It wasn't long before the small dry-goods shop became a block-long department store covering 684,000 square feet. Its collection of iron-front buildings made Lits an architectural landmark. Lits had a loyal customer base and was proud to call itself "A Great Store in a Great City."

Lit Brothers was viewed as a step below Gimbels and catered to the working-class customer. "Even though Lits was down priced, there were certain merchandise categories, like lingerie and foundation garments, where it didn't matter who you were in Philadelphia. You went to Lits first," says Mercia Grassi.[48] For many customers, Lit Brothers was a comfortable store and it was a busy Market Street destination.

In 1928, the City Stores corporation acquired Lit Brothers. It ran its own radio station, WLIT, which broadcast music and stories three nights a week. It merged with Strawbridge's radio station, WFI, in 1934 and created the popular Philadelphia radio station WFIL. There were periods of time during the 1930s and 1940s when Lits had the highest volume of sales of all

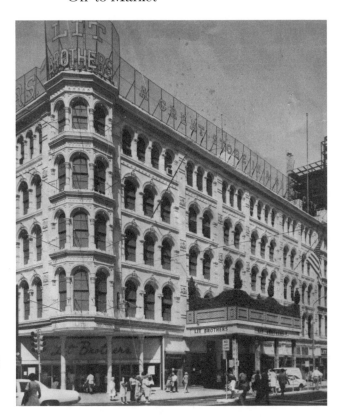

The historic Lit Brothers store at Eighth and Market Streets, as it appeared during the nation's bicentennial. *Courtesy of the author.*

of the Philadelphia stores. In 1959, Lits was awarded Brand Name Retailer of the Year by a group of national retailers.

Lit Brothers expanded by opening branch stores in urban areas. It opened stores in Upper Darby, Trenton, Northeast Philadelphia and Camden, eventually scouting shopping center locations. The business grew to include eleven stores employing four thousand workers.

SNELLENBURGS

Nathan Snellenburg opened his small men's store in 1873 on Philadelphia's South Street. In 1889, Snellenburg expanded his retail operations by opening a full-fledged department store in the landmark location at Twelfth and Market Streets. The store continued to grow and, in 1943, opened its Chestnut Street addition, which company advertising referred to as the Store of Tomorrow. The company remained in the family hands until the

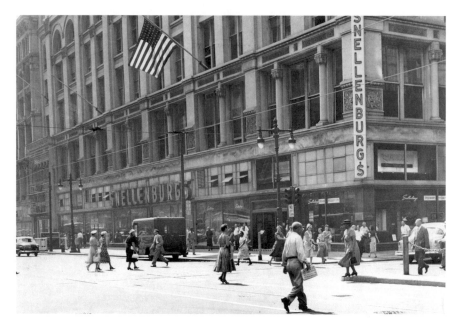

Snellenburgs Center City store at Twelfth and Markets Streets. *Courtesy of Temple University Libraries, Urban Archives, Philadelphia, Pennsylvania.*

Bankers Securities Corporation purchased it in May 1951. In addition to Snellenburgs, Bankers Securities also operated the Philadelphia area Bonwit Teller stores. The Philadelphia Bonwit Teller stores had severed their ties with the New York Bonwit Teller stores back in 1933. It wasn't until August 1963 when Bankers Securities relinquished control of the Philadelphia Bonwit Teller stores that the two Bonwit divisions were finally reunited.

Like Lits, Snellenburgs catered to the working-class customer. Snellenburgs branched out from Center City and opened locations in Willow Grove (1953) and on Oregon Avenue in South Philadelphia (1954). In August 1958, Snellenburgs purchased Atlantic City's M.E. Blatt Co. The eight-story store built in 1920 on Atlantic City's Atlantic Avenue was renamed Snellenburgs-Blatt and became the largest department store in southern New Jersey. Snellenburgs also opened a store in the Lawrence Park Shopping Center and operated four tire centers.

On January 31, 1962, Lit Brothers acquired Snellenburgs's four branch stores. City Stores and Bankers Securities were already related in ownership and, with Lits and Snellenburgs targeting the same customer, it was a natural fit. Snellenburgs continued to operate the single Center City flagship, concentrating on merchandise quality and customer service at Twelfth and Market Streets.

Off to Market

As a single store operation, Snellenburgs posted heavy losses. Sales at the Center City store fell by over 25 percent in one year. At 2:00 p.m. on February 15, 1963, customers were escorted out of the store and the five hundred employees were called to gather in the auditorium. Snellenburgs abruptly closed its doors, ending ninety years of service to Philadelphia.

FRANK & SEDER

Frank & Seder was a Pittsburgh department store that opened a Market Street store in 1915. Joseph Frank and Isaac Seder opened their Pittsburgh store in 1907. In addition to the Pittsburgh and Philadelphia stores, Frank & Seder operated a store in downtown Detroit. In March 1925, Frank & Seder opened a newly rebuilt department store at Eleventh and Market Streets. This twelve-story structure was one of the tallest buildings in the Market Street corridor.

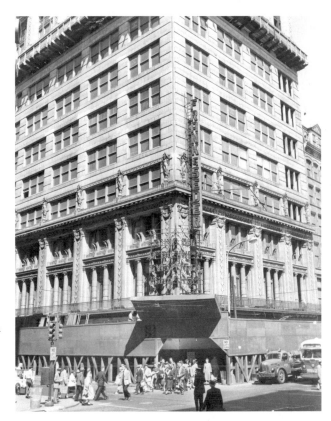

Frank & Seder closed its doors in 1953. The building, shown here in 1957, was demolished in 1959. *Courtesy of Temple University Libraries, Urban Archives, Philadelphia, Pennsylvania.*

Frank & Seder made Philadelphia history when it opened the city's first branch department store on October 2, 1929. This store, located at Sixty-ninth and Ludlow Streets in Upper Darby, contained sixty thousand square feet of selling space and included an automotive center. Fifty-four thousand shoppers passed through the train station at Sixty-ninth Street every day on their way to Center City. Frank & Seder hoped to capture some of that customer base.

In 1941, Frank & Seder inaugurated WALnut 9100, a telephone number that featured the Audichron Machine. Philadelphians would set their watches and clocks to Mary Moore's voice, courtesy of Frank & Seder. In October 1949, Frank & Seder lost the lease on its marginally profitable Upper Darby branch to Lit Brothers. Through better merchandising and physical modernization, Lits was able to triple the store's sales volume within one year. But on November 4, 1953, National Department Stores, Frank & Seder's parent company, announced that it was closing the Market Street store. A company statement said, "To Philadelphia the loss of Frank & Seder is a major one, and with the passing of the Earle Theater just across Market St., a great many will feel nostalgic in recognition of the two landmarks."

Four hundred employees lost their jobs with the closing. Philadelphia's smallest department store, at 250,000 square feet, was the first of the Big Six Market Street stores to close. Frank & Seder locked the doors of its Detroit store in June 1951 and closed its Pittsburgh operations in December 1958 due to an "unlivable rent situation." The Philadelphia site was cleared in 1959 for a parking garage and Philadelphians were no longer able to "Follow the Leader to Frank & Seder."

Opening Some Stores, Closing Some Doors

There was this great feeling of quality when you entered the store. Even the name of the store inspired confidence.
—*Pat Ciarrocchi, news anchor, KYW-TV*

By the late 1940s, most large American department stores either began opening branch stores or began planning branch stores. After the war, many Americans left cities in exchange for life in the suburbs. Retailers had to follow their customers, and the age of the suburban department store began. Layout convenience and free parking provided unlimited possibilities for department store branches. It was time for Wanamaker's to look ahead and search out potential locations for suburban growth. Wanamaker's set its sights on Wilmington, Delaware.

Wilmington was a fast-growing city that was grossly underserved by large department stores. The city was home to small stores such as Crosby & Hill, Kennard-Pyle, H. Braunstein and famous discounter Wilmington Dry Goods. Crosby & Hill dated from 1878 and operated its department store at Sixth and Market Streets. It abruptly closed its doors due to "financial strain" in March 1960. Kennard's was one of Delaware's oldest retailers and was founded in 1846. Headquartered at Seventh and Market Streets, Kennard's eventually became a chain of six department stores. Its last store, the flagship store on the Market Street Mall, closed in March 1986. Braunstein's, Delaware's Fashion Capital, opened its Market Street store in 1917. It opened branches in locations such as Price's Corner, Dover and Rehoboth Beach and eventually ceased operations in 1985. The Dry Goods

was a popular, no-frills retailer that was founded on Market Street in 1924. The store began adding suburban Wilmington stores but the antiquated Wilmington flagship store was shut in 1974. The rest of the company grew to eight locations throughout the Delaware Valley until most stores were sold to Value City in May 1989.

In September 1947, Wanamaker's unveiled architectural plans for its first branch store. Located on the Augustine Cut-Off, Wanamaker's Wilmington was to be an eighty-thousand-square-foot building with a "country club atmosphere." The store planned to open in 1950 and would be located in a mostly suburban area. Wanamaker's searched for other sites closer to the inner-city Wilmington core but it chose this noncommercial address. Built of fieldstone and white brick, the store would be "surrounded by broad lawns, formal gardens, terraced walks, and have two parking areas concealed from public view by landscaping."[49] After the company completed a house-to-house survey of the Wilmington area, Wanamaker's decided to double the size of the store in order to meet the potential demand.

On November 15, 1950, the $6 million Wanamaker's Wilmington store opened its doors. Five hundred employees helped serve the thirty thousand

The graceful Wilmington, Delaware, John Wanamaker store, pictured here in 1991. *Courtesy of the author.*

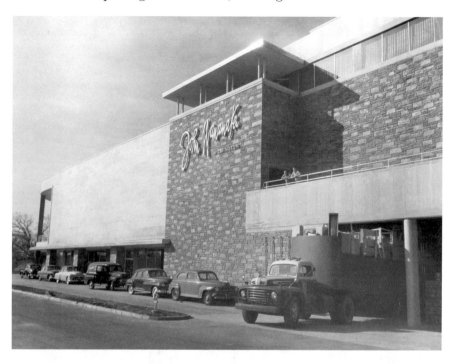

Trucks deliver merchandise in preparation of the Wilmington store's opening in November 1950. *Courtesy of Temple University Libraries, Urban Archives, Philadelphia, Pennsylvania.*

people that came to shop at the store. The local newspaper spoke of the famous Wanamaker's traditions that were carried through to the Wilmington location.

> *The Wanamaker eagle and organ, familiar to thousands of Delawareans who have shopped in the Philadelphia store, will be part of the fixtures of the new retail outlet. They are located on a platform midway between the first and second floors, just off the main stairway at the front of the store. Chairs have been furnished so that shoppers who tell their friends to meet them "at the eagle" will be able to wait in comfort. The chairs and mezzanine have been decorated with flowers for the opening.*[50]

Customers were able to enjoy "superb food in quiet, relaxed, pleasant surroundings" in the store's Ivy Tea Room.

The Wanamaker's Wilmington store was very successful. Wanamaker family member Christopher Kellogg recalls that there was a different merchandise mix in Wilmington than in the other stores. "Wilmington had some funny quirks about it. I remember that Wilmington carried a quilted

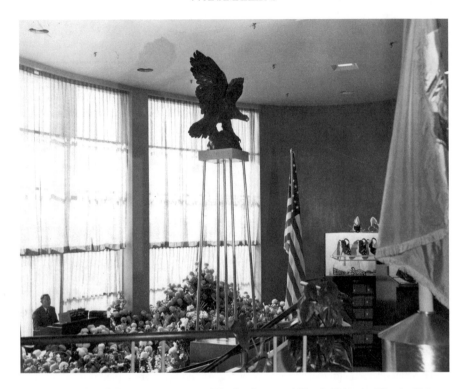

A rare view of the Wilmington organ and Eagle. *Courtesy of Temple University Libraries, Urban Archives, Philadelphia, Pennsylvania.*

jacket for women. They were disgusting looking things that gave you no figure and made you look 20 pounds heavier. There were things that sold in the Wilmington store and nowhere else," says Kellogg. CBS3 news anchor Pat Ciarrocchi grew up in Kennett Square and spent her youth shopping at Wanamaker's in Wilmington.

> *I was always attached to the Wanamaker's store in Wilmington. I could get there with my eyes closed. I can see it with the curved shape and the guy in the window playing the organ. As a kid, I would stand on the balcony and listen to the organ. I remember standing there for the concerts at Christmas. It was always so much fun because that organ had a great sound.*[51]

Ciarrocchi continues to say "if you were to go shopping for school clothes, if you were to go get a special gift, if you were to go have a really great afternoon and have lunch with your mom, you went to Wanamaker's."

Opening Some Stores, Closing Some Doors

After Wanamaker's settled in with their new Wilmington store, the company turned its attention to the New York operation. By the 1950s, the New York store was no longer making any money. "It didn't know the New York market," says Kellogg. The New York Wanamaker's was seen as a very provincial store but was still respected among New York shoppers. Former Philadelphia newscaster Trudy Haynes grew up in Harlem and would go to the New York Wanamaker's with her aunt.

> *It was an outing to go to Wanamaker's. You had to get dressed up. The store had crystal chandeliers and had music floating through the store. It was very soft spoken. It was a very elegant store. We would just float through the store, not that we could afford to shop there.*[52]

Part of the problem with the New York store was its size. "The store was just too big and it had too much merchandise and too much space. It was like two of the Philadelphia stores and it went across the street. It just went on and on," says Louise Wanamaker.[53] In 1951, the company began the

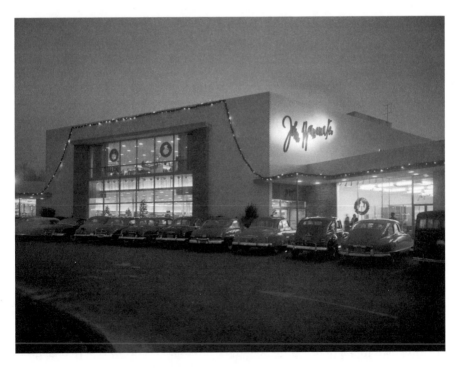

The exterior of the Great Neck, Long Island, Wanamaker's store from December 1951. *Courtesy of the Gottscho-Schleisner Collection of the Library of Congress.*

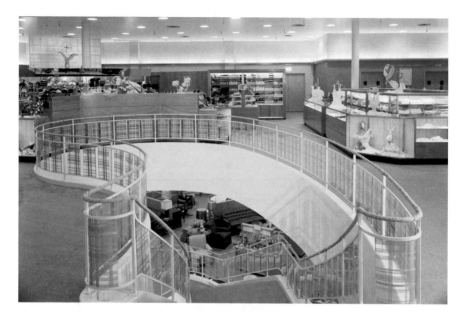

The grand staircase at the Great Neck Wanamaker's store. The signature Wanamaker Eagle can be seen in the upper left corner. *Courtesy of the Gottscho-Schleisner Collection of the Library of Congress.*

process of pulling out of the old A.T. Stewart building and consolidating all business into the South Building dating from 1907. President John E. Raasch defended the consolidation and insisted there were no plans to pull Wanamaker's out of its downtown location. He said the store was located in an excellent shopping area that was being supported by new housing.

Wanamaker's was eager to assure New York shoppers that it was committed to the New York metropolitan area. The company chose a plot of land in Westchester County as a site for another suburban New York store and it opened its Great Neck, Long Island, branch location on May 16, 1951. The Wanamaker's Great Neck store contained 45,200 square feet; it was roughly one-third of the size of the Wilmington Wanamaker's. The store was too small and quickly proved to have inadequate selection for shoppers. "I was at Great Neck for the opening but I wasn't there for the closing, which took place shortly afterwards," says Christopher Kellogg. "It never worked to begin with. It was a bad location."[54]

Richard C. Bond became president of Wanamaker's in 1952 and was charged with fixing many of Wanamaker's problems. He stressed the need for Wanamaker's to be more proactive in suburban growth. One of Bond's first

big decisions was to move the Philadelphia Men's Store back into the Main Store. The Lincoln-Liberty Building, home of the Men's Store, was sold to Philadelphia National Bank. PNB intended to convert the building into its new headquarters. The Men's Store moved to the second floor of the Chestnut Street side of the Wanamaker building. Actor and singer Danny Kaye opened the new Men's Store on March 2, 1954, and the store proudly advertised that it had "the largest stock of men's furnishings in the history of Wanamakers."

The New York Wanamaker's continued to be a drain on the company, and the headquarters in Philadelphia grew impatient with its performance. "The Philadelphia Board of Directors didn't care for the New York store. They didn't like New York in general," says Christopher Kellogg. The New York store had a ninety-nine-year lease, and the Wanamaker Trustees saw that lease as "an albatross around their neck." The employees' union took a more active role in the New York store, which increased tensions with the Philadelphia headquarters.

On October 25, 1954, Wanamaker's announced that the New York store would close its doors. The company said that its future was in the suburbs and vowed to keep the Great Neck store open. Wanamaker's also said that they remained committed to the new Yonkers branch, then under construction. The Liberty Street store would also remain open to serve New

The Wynnewood Wanamaker's store as seen in July 1995. *Courtesy of the author.*

71

York customers. Local 9 called the decision "hasty" and noted that eighteen hundred employees would lose their jobs. Campaigns were launched to save the store and Local 9 took charge. In a letter to employees dated November 5, 1954, Local 9 encouraged everyone to "pull together and save that grand old store worth one of the finest names in retailing. In union there is strength—united strength to build, not to liquidate."[55]

In the meantime, Wanamaker's opened its third branch on November 15, 1954, in the Main Line Philadelphia community of Wynnewood. Along with Bonwit Teller, the 163,000-square-foot store helped anchor a shopping center. The Wynnewood Wanamaker's was a success from the start. "It was a great little store," says Kellogg. The success of Wynnewood helped offset the troubles with the New York store closure.

On December 18, 1954, the New York Wanamaker's ended its run after fifty-eight years. The once quiet and elegant store was the scene of last-minute bargain hunting. It was an undignified ending for a noble store. Employees expressed shock and sadness about the store's final hours.

One employee told a newspaper reporter:

> *You'd be amazed at how many people come up to me and say how sorry they are. People who came here for years, not just to buy, but to see their friends. These are the real John Wanamaker customers. The others—the ones who've showed up today and yesterday, like going to a funeral—they crawled out from under some rock.*[56]

That same day, the Wanamaker Board of Directors received a letter from furrier Victor Asselin. He attacked the company for closing the store. "For a store with the name of Wanamaker to admit failure in New York is beyond comprehension. If any of you get more than a dollar a year, you are grossly overpaid. All you had to do was move!" said Asselin.[57]

Wanamaker's also reversed its future plans for the small Great Neck store. In April 1955, the store's lease was sold to Stern's and a liquidation sale began. On May 5, 1955, the 112 employees of the Great Neck store lost their jobs.

Even before it opened, Wanamaker's tried to sell the lease of its Yonkers branch to Macy's but an acceptable deal with the shopping center's landlord could not be reached. The company's plans went forward and on April 28, 1955, the Cross County Shopping Center store in Yonkers, New York, opened for business. The store proved to be successful and it anchored the center with Gimbels. Wanamaker's merchandise was a higher level than

TO OUR FRIENDS,
CUSTOMERS AND EMPLOYEES

Today, December 18th, 1954, the doors of the main store at Broadway and 8th Street will close to be opened no more as a John Wanamaker Department store. We regret beyond words the turn of events which has brought this about.

With the utmost sincerity at our command, we express our heartfelt thanks for the loyal and understanding patronage of our customers throughout the 58 years of our business life at this location; for the good and faithful service our employees have given to the store and its customers; and for the respect and esteem which the community at large has unfailingly shown.

During our sojourn here there have been clouds as well as sunshine, but the sunshine has mostly dispersed the clouds and on the whole ours has been a happy and satisfying experience amid harmonious relationships. It is with a heavy heart that we bid all a last farewell.

John E. Raasch
Chairman of the Board
John Wanamaker Philadelphia and
John Wanamaker New York

Executive Offices

A letter to the New York Wanamaker's employees and customers on the day of its closing on December 18, 1954. *Courtesy of the author.*

The entrance to the Yonkers Wanamaker's store at the Cross County Shopping Center. This photograph was taken in April 1956. *Courtesy of the Gottscho-Schleisner Collection of the Library of Congress.*

Gimbels's but it wasn't as expensive as Lord & Taylor and B. Altman. The store, and its merchandise, was perfect for Westchester County.

The Yonkers Wanamaker's was very profitable. Part of the success was due to its location just outside the city limits, thus making it outside the taxing zone. "It was a place where people went to save on their sales tax," says Christopher Kellogg. For decades to come, it was Wanamaker's sole department store operation in the New York metropolitan area.

On July 15, 1956, a five-alarm fire broke out at the old A.T. Stewart building at the former New York Wanamaker site. Six hundred firemen battled the city's worst fire in twenty-one years. During the fire, the Lexington Avenue subway filled with water and the roof of the Astor Place subway station was reported "unsteady and vibrating." The street around the store was in danger of collapsing. The following day, Meyer Berger wrote a column in the New York Times commenting on the old Wanamaker's and the fire that devastated the building.

An interior view of the Yonkers John Wanamaker store. The photograph was taken in January 1995. *Courtesy of the author.*

Its soft spoken salespeople, its suave—but not too suave floorwalkers, its mellow indoor bells, the concerts in the great Wanamaker Auditorium, the air of quiet gentility that always lay, sort of reverent and hustled, over its well-stocked counters. Now it is suddenly gone.[58]

CHRISTMAS LIGHTS

It was the greatest thing. Your mother put you on the monorail and then did her shopping.
I was into science fiction and, as a kid, it was like being in your own private spaceship.
 —*Joel Spivak, Philadelphia historian*

W anamaker's was always about pageantry and Christmastime was a magical time at the store. As far back as 1896, the stores were draped with elaborate garland and decorated with wax figures of Santa Claus. In the 1920s, Wanamakers began its Christmas Carol sing-along tradition, held on Christmas Eve. Employees and customers gathered in the Grand Court and sang along with the famous Wanamaker organ. At the same time, Santa Claus took up residence in both the Philadelphia and New York stores. But there were two special traditions that made Wanamaker's a Philadelphia Christmas destination that lasted for generations.

THE MONORAIL

By the end of the 1940s, space travel was a fascination for many young people. In 1948, Wanamaker's installed a monorail in the toy departments at both stores.[59] In Philadelphia, the monorail ran along rails suspended on the ceiling of the store's large eighth-floor toy department. The cars were designed for children eleven years old and younger and first operated as the Rocket Express. Every few years, the name of the monorail was changed to reflect what was popular at the time. Names included the Solar Express, the

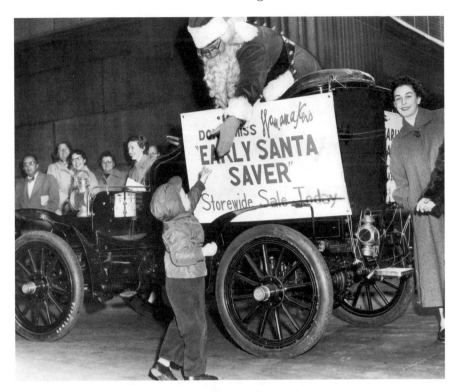

Santa announcing an early Christmas sale on November 8, 1954. *Courtesy of Temple University Libraries, Urban Archives, Philadelphia, Pennsylvania.*

Skyliner, Santa's Express and the Satellite Express. One year the monorail was decorated as a caterpillar, complete with antennas on its front car.

The cost of the ride was nominal and it became a popular attraction at the store. When the New York store closed, the monorail cars were moved to the Philadelphia store. When the new cars arrived, Philadelphia children's personality Sally Starr was there for the new addition. "I was the first person to ride the 'choo choo train' and it was such a thrill. After all, I'm a kid at heart," says Sally.[60] The Wanamaker's stores were not the only department stores to have a monorail at Christmastime. Portland's Meier & Frank, Newark's Bamberger's and Grand Rapids's Herpolsheimers stores were other businesses that featured a similar attraction. The Wanamaker's monorail was perfect, luring children and their parents past the Eagle and Light Show. A special express elevator took the parents and children right up to the store's eighth floor toy department. The monorail didn't even interfere with the buying space of the Biggest Toy Department on Earth.

An early ticket for the Wanamaker's monorail. *Courtesy of Joel Spivak.*

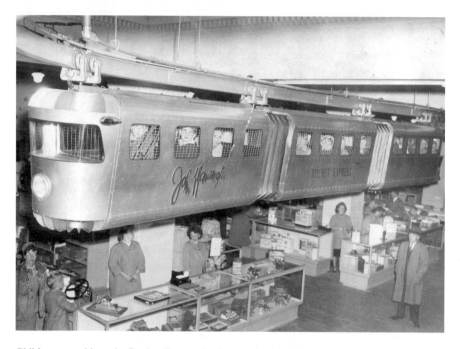

Children crowd into the Rocket Express in the store's eighth-floor toy department. *Courtesy of Temple University Libraries, Urban Archives, Philadelphia, Pennsylvania.*

In 1963, the monorail changed its name to the AMF Monorail Jr., referencing the upcoming World's Fair where the futuristic AMF Monorail was prominently featured. The monorail cars were painted in World's Fair pink, blue and white. Officials from AMF remarked on the similar appearance of the two monorails.

It was a tradition for the Toy Buyer to ride the monorail on Christmas Eve before the store closed for the day. Christopher Kellogg served as the Toy Buyer in the early 1970s. Speaking of his first monorail ride, Kellogg

Visit The Carnival of Toys. Ride the real Carousel, high flying Satellite Express and choose exciting toys. Ride the escalators to the eighth floor.

The Satellite Express is featured in this Wanamaker's advertisement from the late 1950s. *Courtesy of the author.*

says, "I was terrified. The damn thing went over the stock rooms and all I saw was dirt and dust. I would have done something about it had I known." When Kellogg first began to work in the toy department he was told to watch where he stood whenever the monorail was near. "Kids would bring straws and hit you with a spit ball, if you weren't careful."[61]

During the off months, the rails remained on the ceiling but the cars were hidden behind a wall. The monorail continued to operate until 1984. It was last called the Rudi Express, named after the Wanamaker's Christmastime bear. By then, the cars were filthy and rusting. They appeared to have crashed into each other over and over. Historian Joel Spivak put together a plan to restore the monorail and celebrate its history with celebrity appearances and displays. The store seemed interested but the plan was later shelved. Eventually Spivak got a call from a woman at Wanamaker's who remembered meeting him a few years earlier. She told him, "I'd like you to know that the monorail is about to be demolished and the store is going to have to chop it up in order to get it out of the building."[62] Spivak called Philadelphia's Please Touch Museum and organized a restoration campaign that included carrying the heavy cars down eight flights of stairs and removing the forty to fifty coats of paint that were on the cars. The restored cars are now permanently on display at the museum.

The monorail ended its run as the Rudi Express in 1984. By then, the cars were dirty and damaged. *Courtesy of Joel Spivak.*

After they were removed from the store, the monorail cars were painstakingly restored. Almost fifty coats of paint were stripped from the cars. *Courtesy of Joel Spivak.*

The restored monorail is displayed for the first time. It was moved to its permanent home at the Please Touch Museum in Philadelphia. *Courtesy of Joel Spivak.*

THE CHRISTMAS LIGHT SHOW

In 1948, Frederick Yost joined the staff at the Philadelphia Wanamaker's. He was a graduate of Yale University with a background in theater. In 1952, he was put in charge of sales promotion. Yost staged special events in the store and, in 1956, Wanamaker's celebrated the Magic Land of Christmas in the Grand Court.

The Grand Court was the site of the Christmas Cathedral. The display "represented the sacred story and the brotherhood of Man." The centerpiece was a large three-dimensional tableau of the Nativity, with the shepherds and the Magi at its side. Around the grand court, scenes of the Annunciation, Visitation, Revelation, Adoration, Presentation, and Flight into Egypt were displayed. Accompanying the Christmas Cathedral was Mary Vogt, playing carols on the famous Wanamaker organ. Next to the face of the large organ pipe was the Enchanted Fountains. Presented by Dancing Waters, Inc., the water display was inspired by the fountains at St. Peters in Rome. The waters would rise and fall under colorful lights as the music played.[63]

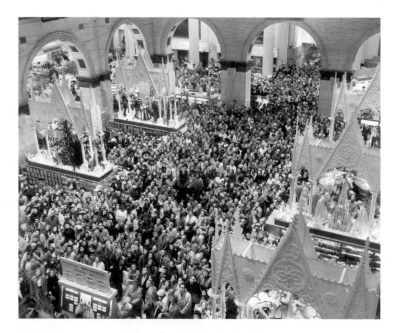

Crowds gather in the Grand Court in preparation for a light show presentation. Scenes of the Christmas Cathedral are on display above the merchandise. *Courtesy of the author*.

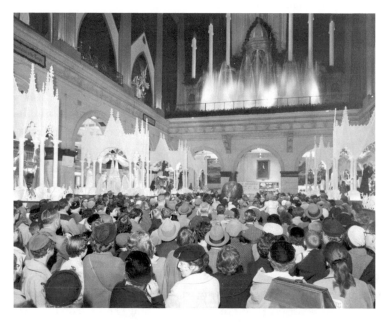

A 1957 image of the Christmas Cathedral and Dancing Waters display. The organ console can be seen in the upper left-hand corner. *Courtesy of the author.*

Santa is given a tour of the Dancing Waters display. *Courtesy of the author.*

Each year, Yost would add something different to the program. In 1959, the Magic Christmas Tree "of a million lights" made its debut. The March of the Toys was added in 1961 and Frosty the Snowman arrived in 1964. By 1968, Rudolph, Santa's train and scenes from the *Nutcracker* had joined the show. In later years, Wanamaker's added special touches to the show. When the Phillies won the World Series in 1980, the team made it into the show. E.T. made an appearance in 1983 and the Wanamaker's Christmas mascot, Rudi Bear, began his dance in 1986.[64]

The Pageant of Lights was the official name but everybody simply called it the Wanamaker's Light Show. The entire show featured approximately 80,000 lights, 20,000 alone on the Magic Christmas Tree. The fountain display utilized 2,300 gallons of water. During the grand finale, the show used 288,000 watts of energy. All of the lights could not be used at once as it would overpower the store's electrical system. The power of the lights helped heat the store's Grand Court.

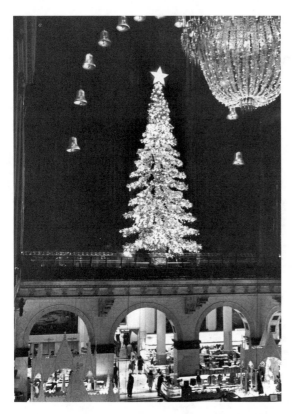

Left: By 1962, the Christmas Light Show becomes more elaborate. *Courtesy of Temple University Libraries, Urban Archives, Philadelphia, Pennsylvania.*

Below: A close-up view of the Christmas Light Show from 1976. *Courtesy of Temple University Libraries, Urban Archives, Philadelphia, Pennsylvania.*

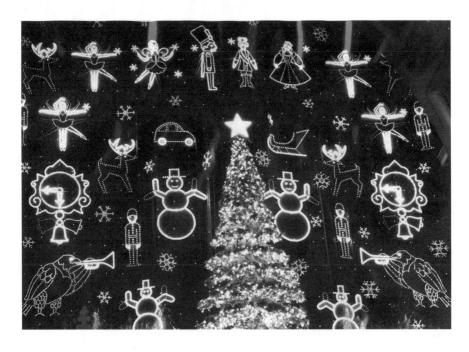

Christmas Lights

By 1966, approximately twenty thousand people a day watched the light show, totaling almost a half million customers each Christmas season.[65] The thirteen-minute show featured the voice of legendary Philadelphia sportscaster John Facenda.

His distinctive voice greeted the audience with the following dialogue, interspersed with music:

John Wanamaker proudly presents our Annual Christmas Pageant of Lights. A brilliant holiday spectacular depicting the color, warmth, and joy of the Yuletide season.

Starring the breathtaking Magic Christmas Tree,

And introducing the story of the Nutcracker. *With a wave of her wand, the Sugar Plum Fairy takes us to the fantastic clock shop.*

And now, thrill to a sleigh ride in the sky,

And now, hop aboard the Santa Special for a train trip to a winter wonderland.

On we go to greet Frosty the Snowman;

Goodbye Frosty, Goodbye.

Christmas, in the Grand Tradition. Our holiday greeting card unfolds before your eyes as John Wanamaker wishes you the Happiest Holiday Ever!

A Sign of the Times

Let me warn you, the Wanamaker store was not the best store for ethnic people. They did not have an open policy of "you all come."
—Trudy Haynes, former reporter, KYW-TV

Across the country, department stores projected an image of catering to all customers' income levels. Practically every store housed a designer salon featuring Paris originals on one of its upper floors, and most included a Budget Basement or a Downstairs Store that accommodated those with a thriftier budget. However, African Americans were not entirely welcome in department stores. This was not just the policy in the Southern stores; it was also the sentiment across the United States.

In most cases, African Americans were allowed to walk through the stores and look at the merchandise. Many stores wouldn't let African Americans try on clothes unless they intended to buy them. Trudy Haynes saw Wanamaker's as "having the best clothing in town." But it was not a comfortable store for her to shop in. Employees followed her through the departments asking, "Are you really going to buy this?" In the 1950s, Trudy Haynes went to look for employment at Wanamaker's and was told that the only job available for her was that of an elevator operator.

African Americans were treated more fairly in some of Philadelphia's other department stores. Gimbels had experience running a store in New York, a city that was home to people of many different backgrounds. In New York, people from all different ethnic backgrounds walked the same streets

and shopped the same stores. "Philadelphia is a little 'Quaker Town' that had its parameters set up," says Haynes.[66]

Of all of the Philadelphia department stores, Lit Brothers was the most accommodating to African Americans. Lits hired employees of all backgrounds and appealed to a more urban clientele. "Lit Brothers became sort of my hangout," says Trudy Haynes. Lit Brothers had a history of operating stores in urban settings. It opened its Trenton store when it purchased Swern & Company in 1949. It served Trenton's working-class, inner-city core until 1967, when the store became too antiquated to warrant further operations. Across the river from Philadelphia, Lits opened a large 180,000-square-foot outlet in the heart of Camden. The store occupied the site of the former Camden County Courthouse. Lits opened the Camden branch in October 1955, just as the city began its long spiral downward. It catered to a down-market customer, and the area surrounding the store reflected it. In January 1970, Lits announced that the Camden store would close its doors. However, store management and the Camden mayor's office reached an agreement that enabled the store to remain open. The city agreed to improve exterior lighting and increase visible police protection around the store. But Lits never survived the aftermath of the August 1971 riots, as residents and shoppers fled Camden. In April 1972, Lits decided that it was not economically feasible to continue business in Camden and the store closed. Lits' store in downtown Atlantic City also served a predominantly urban shopper. By the early 1970s, downtown Atlantic City was a challenging retail environment. Young vandals frequently targeted the store. In 1974, the city's Department of Inspections cited the store for the physical deterioration of the building. The doors of the Atlantic City store remained open until April 1977, just a few months before casino gambling began in the shore resort. In its heyday, Lit Brothers was an extremely popular store. The company knew its customers, and it was one of the few department stores in the Philadelphia area where everybody was truly welcome.

African Americans were not the only group that faced discrimination at Wanamaker's. A number of large American department stores did not hire Jews for positions of higher rank than salesperson. Along with Wanamaker's, stores like Chicago's Marshall Field, Detroit's Hudson's and Minneapolis's Dayton's also followed similar discriminatory hiring guidelines. It wasn't until after World War II that these policies were reversed.[67]

By the late 1950s, the country began to feel the full effect of the atomic age. In February 1958, Wanamaker's displayed a large collection of toy missiles in the Grand Court. The Falcon, an air-to-air missile; the Rascal, an air-to-

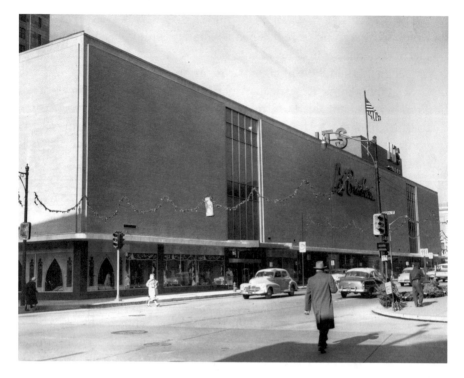

The Camden, New Jersey Lit Brothers store opened in 1955, just before the large New York Shipbuilding Corporation began to eliminate thousands of jobs in this industrial city. The store held its own but closed its doors in 1972, shortly after the Puerto Rican riots of August 1971. *Courtesy of the author.*

surface rocket; the Redstone, a ground-to-ground missile; and the Hawk, a missile that can be fired to a moving aircraft, were all proudly exhibited. Officials from General Electric, *Time* magazine and the Army, Navy, and Air Corps sponsored the show.

On November 22, 1963, KYW news anchor Pat Ciarrocchi was shopping with her mother at the Wilmington Wanamaker's. As they shopped, a loud speaker interrupted with, "Ladies and Gentlemen, we have an announcement to make: the President has been shot."

"At first I thought they were fooling. I thought that it couldn't possibly be true," says Ciarrocchi. "Everybody just went stone cold. It was a really upsetting thing to hear. I remember them saying it a second time and everybody kind of scattered."[68] President Kennedy's death will always be associated with the Wilmington store for Pat Ciarrocchi. She gets goose bumps just thinking about it again.

An Eagle Spreads Its Wings

*I loved Wanamaker's. The salespeople at Wanamaker's were extremely nice and they
knew not to call me Miss Starr. It's always Sally.*
—*Sally Starr, Philadelphia children's television host*

Wanamaker's continued to open branch department stores in the
Philadelphia area. On February 27, 1958, Wanamaker's opened a
165,000-square-foot store in the suburb of Jenkintown.

Wanamaker's president Richard C. Bond said:

> *The company can better serve Philadelphia and its suburbs by keeping
> abreast of the expanding volume of potential retail business. To maintain
> the Wanamaker policy of efficient customer service at its usual high level,
> John Wanamaker store facilities will be brought into the rapidly expanding
> suburban communities as they develop.*

Jenkintown was a very successful and popular store. For many years, it was
the company's most profitable branch.

Sales at the Center City department stores continued to decline during
the 1950s. Wanamaker's was careful to maintain an image of balance
between running its Center City store and putting effort into branch
development. In a speech to the Wanamaker's Board of Trustees on May
21, 1958, John R. Wanamaker assured the members that the success of the
Center City store was the number one priority for the company.

Wanamaker said:

Above: The Jenkintown Wanamaker's was once the crown jewel of all of the branch stores. It is pictured here in 1995. *Courtesy of the author.*

Left: John Wanamaker opened up the Queen Mary Laboratory in 1880. Queen Mary was one of Wanamaker's signature house brands for many decades. *Photograph by Christian Colberg. Courtesy of the author.*

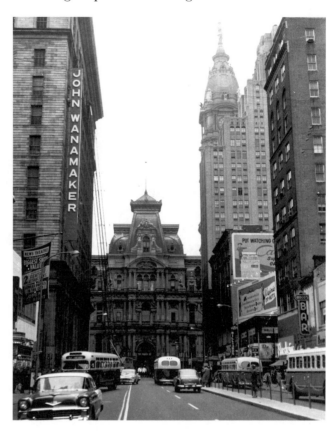

The Market Street view of the Center City Wanamaker's store. The vertical John Wanamaker sign was dismantled in 1959. *Courtesy of the Historical Society of Pennsylvania.*

The old saying "the tree is only as good as the trunk" seems to well typify our organization. Our branches draw from the trunk and our trunk is strong. One could say 'cut down the tree and where are the branches?' We agree with this theory and we have continued faith in our main store.[69]

Wanamaker went on to recognize the Center City store as a "stellar Philadelphia attraction." President Bond agreed by saying "I feel that while most of the emphasis today is on suburban living, and although there has been tremendous development in our suburbs, we should not forget that we have a responsibility toward our city dwellers."

Even after the New York Main Store closed its doors in December 1954, Wanamaker's continued to operate its small Liberty Street location. A number of buyers from the Main Store relocated to Liberty Street, and the four-story, forty-five-thousand-square-foot store continued to draw loyal Wanamaker's customers. However, in 1958, the lease on the Liberty Street

The Wm. H. Wanamaker store was located just a stone's throw from the John Wanamaker store on Philadelphia's Chestnut Street. It is pictured here in 1958 before the renovation of its storefront. *Courtesy of the Lawrence S. Williams Inc. Collection, the Athenaeum of Philadelphia.*

The logo of the Wm. H. Wanamaker stores was somewhat similar to that of the John Wanamaker stores. The stores were under completely separate ownership. *Courtesy of the author.*

store expired and the Philadelphia headquarters wanted to discontinue the location. Francis Kellogg, a Wanamaker family member and store manager, offered to take over the store but the building's landlord wanted the Philadelphia headquarters to guarantee the lease. They finally agreed to grant Kellogg use of the Wanamaker name with the condition that Philadelphia maintain a 50 percent ownership of the business. "Philadelphia initially didn't want any part of it because they didn't want any liability," says Francis's son, Christopher Kellogg. In the end, the arrangement worked out and the Liberty Street store thrived for many years.[70]

Under President Bond, Wanamaker's was considered among the top two most profitable department stores in the country. The store held special fairs and festivals to draw customers into the Center City store. A World of Imports Fair brought espresso from Italy, Steif toys from West Germany and Japanese dolls to Philadelphia customers. Over the years, the contributions of exotic countries from Vietnam to Israel were celebrated. Whenever a

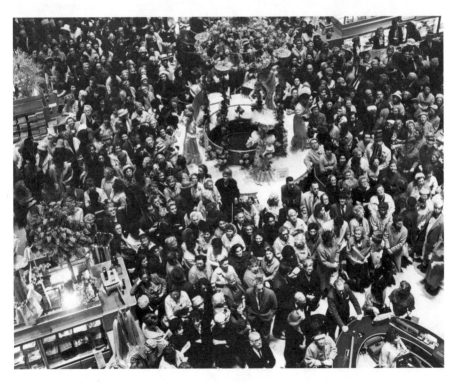

A crowd gathers in the Grand Court waiting for the arrival of Princess Grace Kelly of Monaco on April 22, 1963. *Courtesy of Temple University Libraries, Urban Archives, Philadelphia, Pennsylvania.*

Also in 1963, Bob Hope receives the key to Wanamaker's while Public Relations director Reeves Wetherill reads Hope's book *I Owe Russia $1,200. Courtesy of Temple University Libraries, Urban Archives, Philadelphia, Pennsylvania.*

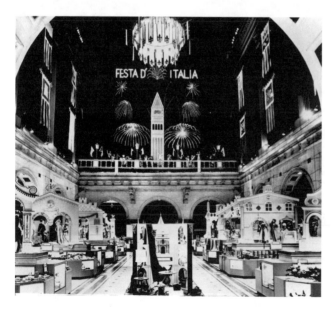

Electronic fireworks and imported Italian goods were some of the highlights of Wanamaker's Festa D'Italia. *Courtesy of the Historical Society of Pennsylvania.*

celebrity visited Philadelphia, it was customary to make a noon appearance in the store's Grand Court. Wanamaker's hosted stars such as Shirley Temple, Princess Grace, Liberace, Frankie Avalon, Fabian, Jane Fonda and Rudy Vallee in the Center City store.

On October 11, 1961, the Cherry Hill Mall welcomed thousands of shoppers in Delaware Township, New Jersey. Strawbridge & Clothier was the center's anchor store. Strawbridge's had been working closely with famed shopping center designer Victor Gruen to bring a new type of shopping experience to the Philadelphia area. Gruen originated the covered mall concept in 1956 when Minneapolis's Southdale Center opened for business. "Gruen's idea of stores facing each other, across an enclosed mall—a garden-like street of trees and flowers, courts and fountains, and benches for strollers—was the perfect premise for the mercantile environment of quality that Strawbridge must have."[71] Over fifty stores joined Strawbridge & Clothier in Cherry Hill. Cherry Hill became a shopping destination for shoppers as far away as New York and Washington, D.C., and the mall at Cherry Hill was the largest regional all-weather enclosed mall on the East Coast, south of New York.

When the developers of Cherry Hill wanted to have a second anchor store, they had to run the decision by the officials at Strawbridge's. Strawbridge & Clothier decided to offer that opening to Bamberger's. Bamberger's was a Newark, New Jersey-based department store that was a division of R.H. Macy. Bamberger's was a successful retailer in the northern half of New Jersey with nine department stores; Cherry Hill was its first southern New Jersey location. Strawbridge & Clothier and Bamberger's proved to be the perfect match, shutting out potential Philadelphia department store competition at Cherry Hill.

Bamberger's at Cherry Hill was a popular Philadelphia area shopping destination. Professor Mercia Grassi was a fan of Bamberger's. "It was a breath of fresh air. They knew their customer," says Grassi. Grassi praised Bamberger's "phenomenal" Executive Training Program. "They knew what they were doing at a time when many major retailers didn't know what they were doing," says Grassi.[72]

Wanamaker's needed to make a move in order to address the success of Cherry Hill and the concept of an indoor shopping mall. The company began selling off some of its excess Center City real estate in order to finance the construction of more branch stores. In September 1961, Wanamaker teamed up with Gimbels and announced plans to develop an indoor shopping mall in Moorestown, New Jersey. It would be the first shopping center in the

A sketch of the Moorestown Mall John Wanamaker store. *Courtesy of the author.*

Philadelphia area that would be anchored by two Philadelphia department stores. In 1963, Wanamaker's opened its 190,000 square foot Moorestown Mall branch. It was constructed of Mansota marble and Avondale granite that kept "the same architectural feeling as the Wanamaker stores in other suburban areas."[73]

Moorestown Mall struggled to compete with Cherry Hill. Strawbridge & Clothier continued to partner with shopping center developers. In every instance, Strawbridge's effectively shut out the other Philadelphia department stores. Wanamaker's, Gimbels and Lits found themselves defending their market share and finding lesser shopping centers within which to locate their stores.

On August 16, 1965, Wanamaker's welcomed forty-one hundred shoppers at its newest branch store in King of Prussia, Pennsylvania. The King of Prussia store was located in a large shopping center with J.C. Penney, E.J. Korvette and Gimbels. The freestanding Wanamaker's store was octagon-shaped in design and featured an "air door" that freed the building of permanent doors. The centerpiece of the King of Prussia store was its Eagle. Every Wanamaker store featured an eagle as an acknowledgement of the Philadelphia headquarters. The King of Prussia location housed an

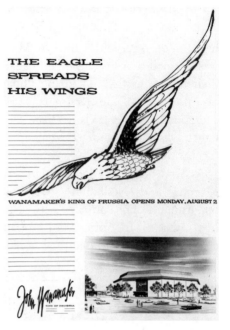

The King of Prussia Wanamaker's store featured an unusual "eagle in flight," suspended over the main floor. *Courtesy of the Historical Society of Pennsylvania.*

A list of Wanamaker's branch locations and their opening dates taken from a 1966 employee manual. *Courtesy of the author.*

eagle in flight, designed by artist and sculptor Henry Mitchell. Mitchell cast his 10-foot, 450-pound bird in Milan, Italy. Wanamaker's stated that "it was decided that instead of an eagle around which people gather to meet their friends as they do in the Philadelphia store, the new one would fly over the heads of the customers, suspended three floors above in the central octagonal court, and visible from all the doors and escalators."[74] A marble bench was placed under the eagle so that people would still have a place to meet while in the store.

As Strawbridge & Clothier marched into the successful malls like Plymouth Meeting and Neshaminy, Wanamaker's scrambled to find suburban opportunities. The company's efforts to locate a store in Springfield constantly met obstacles. In April 1968, Wanamaker's and Gimbels teamed up once again and announced that they would anchor the new Harrisburg East Mall.

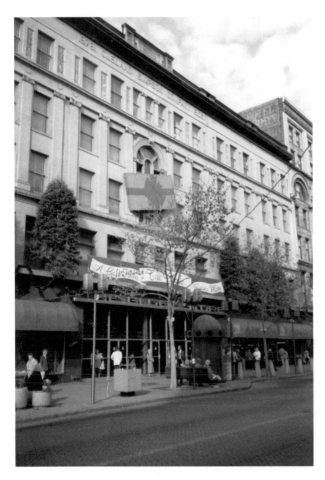

The Globe Store in downtown Scranton, as it appeared during the Christmas 1991 season. *Courtesy of the author.*

A Globe Store credit card from the 1980s. *Courtesy of Barbara Caldwell.*

Wanamaker's said that the new Harrisburg store "will carry the same high-quality merchandise which we have in our Philadelphia store and, as in all Wanamaker stores, service will be the hallmark of our dealings."[75] Louise Wanamaker recalls visits to the Wanamaker's Harrisburg store. "I liked Harrisburg a lot because it was a nice, homey store. It was different," says Wanamaker.

Wanamaker's began to look past the immediate Philadelphia area for expansion. The company set its sights on Scranton. On August 21, 1968, Wanamaker's purchased Scranton's Cleland Simpson stores. Cleland Simpson operated the Globe Store in Scranton and the Isaac Long store in Wilkes-Barre. Industry experts called the acquisition shrewd. The Globe Store dated from 1878 and produced $15 million in annual sales; it was extremely popular in Scranton. The Globe Store brought escalators to Scranton in 1936 and its downtown store was completely modernized in 1950. That renovation included air conditioning and a new storefront. In 1955, Cleland Simpson purchased the Isaac Long store, which was founded in 1874. In 1968, the smaller Isaac Long store earned only $3 million in annual sales. Wanamaker's wanted the Globe in Scranton and so did Lit Brothers. Wanamaker's won the bidding and kept the name of the store—and its management—intact. The Globe Store was a success and Wanamaker's couldn't afford to change that.

CASHING OUT

Thank goodness Carter Hawley Hale purchased us. I wouldn't have wanted to sit with it while it went down. I think department store shopping was over.
—Louise Wanamaker

In 1966, department store retailers planned to revitalize Market Street. Most of the efforts were concentrated around the intersection of Eighth and Market Streets, the home of Strawbridge's, Gimbels and Lits. The grand Market Street East plan was to clean up the street and create a modern shopping thoroughfare between Eighth and Thirteenth Streets, where Wanamaker's was located. Wanamaker's expressed concern that most of the efforts were focused on the eastern end of Market Street but the company still supported any project that would bring shoppers back to Center City.

In late 1966, Gimbels dropped a bombshell, announcing plans to vacate its large Market Street store and move to a modern location between Twelfth and Thirteenth Streets. This angered Strawbridge & Clothier, and a multiyear battle for the redevelopment of Market Street began. Lit Brothers also protested Gimbels's proposed move, concerned that sales at its Eighth Street store would drop considerably.[76]

As trouble developed on Market Street with the other three department stores and their plans for renovation, more trouble brewed inside Wanamaker's. Richard Bond was preparing for his departure as president of the store. Bond helped lead the store by expanding into the suburbs and keeping the Center City store competitive. Bond selected Edwin K. Hoffman to be his successor. Hoffman arrived at Wanamaker's in early 1967

and wanted to make significant changes immediately, starting with its dowdy image. Hoffman did not respect the Wanamaker's traditions, and loyal employees began to fear Hoffman's motives. It was rumored that Hoffman didn't like the older employees, the organ recitals nor the Eagle.[77] He wanted a new Wanamaker's and he wanted this new store to have a new identity.

An article in the April 1989 issue of *Philadelphia Magazine* told the following story:

> *For Philadelphians, getting rid of the eagle would have been like taking Billy Penn from the top of City Hall. Like building condos on Boathouse Row. Like melting down the Liberty Bell. But for Hoffman, the eagle represented the old Wanamakers—the very Wanamakers he was trying to shed. What he hadn't anticipated was that among those Philadelphians outraged at his idea of booting the bird were members of Wanamakers' own board.*[78]

Hoffman was gone the following year, fired by the family that still stood behind the Wanamaker name. The day after his dismissal, the story goes that

Wanamaker's opened its Reading store at the Berkshire Mall in August 1970. The signature eagle statue was located outside of the store on the lower level. *Courtesy of the Historical Society of Pennsylvania.*

Happy Days Are Here Again was played on the Great Organ while employees danced around the Eagle. The store's problems were far from over but its traditions were finally safe.

Shut out of the local malls by Strawbridge & Clothier, Wanamaker's continued to plan stores outside of the immediate Philadelphia trading area. Wanamaker's surveyed the Reading, Pennsylvania, area and on August 10, 1970, opened its newest store at the Berkshire Mall. The success found in Scranton and Harrisburg was not repeated in Reading. Family member and buyer Christopher Kellogg recalls that sales figures from the Reading store were horrible. The store that brought fashions from Paris and London learned that shoppers in Reading were more interested in bobby socks and Keds sneakers.

Strawbridge & Clothier continued to gain strength in the Philadelphia area. Both Strawbridge's and Wanamaker's were family-run businesses but the Strawbridge family still actively managed their company. The Strawbridge family was quick to tell its shareholders that it wasn't going to be lured by

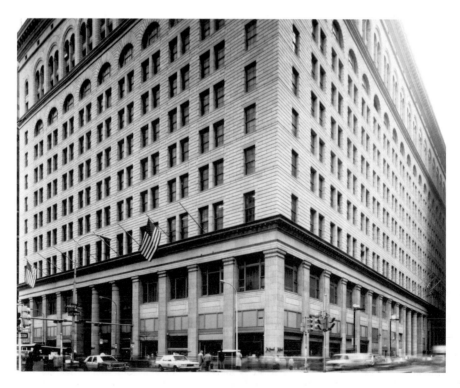

The Center City Wanamaker's as pictured in 1971. *Courtesy of PhillyHistory.org, a project of the Philadelphia Department of Records.*

"untapped but distant markets. We have watched our local competitors move out to Reading and Harrisburg—with less than conspicuous success," said the company.[79] Strawbridge's also cited the "problems of acquiring local identity." On February 25, 1971, Strawbridge & Clothier opened its first Clover discount store on the Marlton–Cherry Hill line. Over time, Clover added greatly to Strawbridge's sales numbers and made the company even stronger.

The year 1972 saw the end of another Wanamaker business. Wm. H. Wanamaker, a chain of Philadelphia men's stores, liquidated their stock. William was John Wanamaker's brother. He purchased the original men's store from John and continued to operate it under his name. At the end, clothing manufacturer and maker of the Botany 500 line H. Daroff Sons owned the store. Daroff filed for bankruptcy and brought Wm. H. Wanamaker to a close. Wm. H. Wanamaker was a classic men's store with high-quality merchandise, but not high fashion. Its closest competition in Philadelphia was Jacob Reeds Sons. "Wm. H. Wanamaker was an upscale store. But you had blue jeans coming in fashion and Brooks Brothers was coming to town. There was not a market niche for Wm. H. Wanamaker anymore," says Professor Mercia Grassi.

Grassi feels that sentiment was part of the department store's downfall. She blames the American shopping mall for the destruction of the higher end retail industry.

Grassi says:

> When the malls came in, along came Mr. & Mrs. Suburban American and their kids. They knew nothing about quality. You didn't have discerning customers so you had no discerning merchandise. It was the beginning of "American slobs" as far as dressing was concerned.[80]

June 1972 saw the end of the Wanamaker-owned Isaac Long store in Wilkes-Barre. A low volume store, Isaac Long never reopened its doors after the devastation caused by the flooding from Hurricane Agnes. By 1973, inflation set in and department stores battled for every dollar. Philadelphia's four major department stores rang up more than $638 million in sales but for the first time, Strawbridge & Clothier beat Wanamaker's for the number one spot.[81] The Center City Wanamaker's store still was the highest grossing department store in Philadelphia, bringing in $78.5 million in annual sales; Strawbridge's at Eighth and Market Streets was next at $45.5 million. But it was a different story with branch store performance. Strawbridge's branch stores averaged $16.4 million in sales while Wanamaker's averaged $13.4

million. Even though Lits' Market Street store outperformed Gimbels, Gimbels's branch stores averaged $10.8 million in annual sales as opposed to Lits' at $7.8 million.

In August 1973, the Wanamaker's Oxford Valley Mall store opened in Langhorne, Pennsylvania, followed by the opening of the Springfield Mall branch in May 1974. Suburban expansion continued in April 1975 when the second Wanamaker's New Jersey store opened at the Deptford Mall. The Deptford Mall store might have been the turning point with the Wanamaker stores and family. The store did not have an image and it did not have customers. "Deptford seemed to be lacking any spark," says Louise Wanamaker.[82] Although the family was not involved with the stores' management, the Wanamaker family increased its draw from the family trust. With declining sales and stores needing renovation, it seemed time to sell the business. The family was advised by Goldman Sachs & Co. to seek a merger or to sell the stores. In late 1975, the family quietly put the stores up for sale.

Center City Philadelphia retail was at a crossroads. Several Philadelphia retail landmarks had closed their doors. Back in the early 1960s, Blauner's closed its popular price store at Ninth and Market Streets. The store stood next to Strawbridge & Clothier and opened its fashion store in 1911. In October 1966, B.F. Dewees wrapped up 108 years of business. A leader in women's ready-to-wear, Dewees had locations on Chestnut Street as well

The company's lackluster branch at the Deptford Mall reinforced the image that Wanamaker's was no longer the market leader. *Courtesy of the author.*

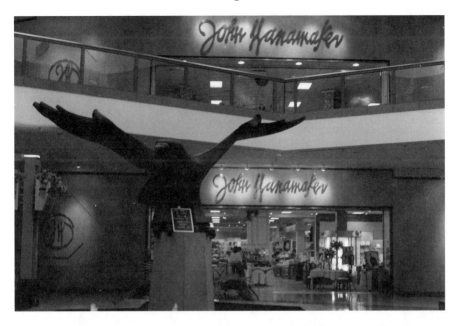

The mall entrance of the Deptford store as photographed in 1995. *Courtesy of the author.*

as Haddonfield, New Jersey, and Drexel Hill, Pennsylvania. Perhaps the biggest blow to Chestnut Street was the loss of the Blum Store. Blum's had an excellent reputation, and its main store was located across the street from Wanamaker's. The high fashion women's specialty store opened branches in Bala-Cynwyd in 1957; Moorestown, New Jersey, in 1971; and in Exton, Pennsylvania, in 1974. Founded in 1920, the Blum Store was known in later years as the Working Girl's Neiman-Marcus.[83] But along with many other parts of Center City's retail district, Blum's lost its cachet and clientele and closed its doors in 1976.

Gimbels planned a new flagship store for Tenth and Market Streets. The five-level store would connect to the Gallery, Rouse's new concept of enclosed inner-city shopping. It was planned to open in the summer of 1977.

In mid-1976, Wanamaker's opened a store at the Roosevelt Mall in northeast Philadelphia, turning away from its upper-crust image. The large 310,000-square-foot store previously operated as S. Klein, a New York discounter. S. Klein closed in 1975 due to financial troubles within its parent company, McCrory Stores. The Roosevelt Mall served predominantly price-conscious, working-class customers, and Wanamaker's tailored the store to meet that market.

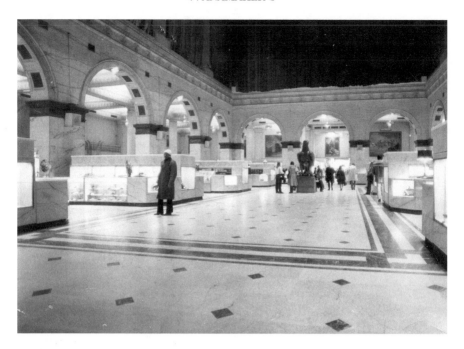

A quiet day at Wanamaker's Grand Court in February 1976. *Courtesy of the Temple University Libraries, Urban Archives, Philadelphia, Pennsylvania.*

The Roosevelt Mall John Wanamaker store was formerly an S. Klein department store. *Courtesy of the author.*

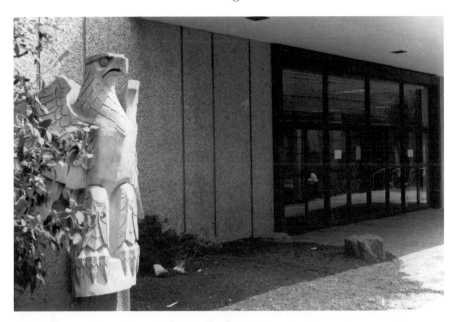

An unusual eagle is displayed outside of the Roosevelt Mall store in northeast Philadelphia. *Courtesy of the author.*

In the past, department stores were the retailing centers of the United States. Department stores also gave shoppers—mostly female shoppers—a social outlet that included shopping and lunch or tea. As society changed so did the department store's role. "It was a time of leisure for suburban women to come into the city," says Professor Herbert Ershkowitz. "When women became occupied with their own professions, they became less occupied by the social nature of consumerism and department stores began to disappear." Issues surrounding parking also played a factor with Center City's overall decline. "With the decline of the city came the decline of the stores," says Ershkowitz.[84]

A bombshell hit the Market Street shopping district in April 1977 when Lits announced that all of its department stores were closing. The store was rumored to be in financial trouble and sources said that it had been losing money for ten years. Lits also struggled to be competitive during the emergence of the discount store revolution. City Stores was eager to pull the plug on Lits. At one point, City Stores even contemplated changing the Lit Brothers name to Maison Blanche.[85] Maison Blanche was the name of City Stores's New Orleans division, and the company felt that a new name could

Milton Berle appears with the company's Reeves Wetherill in the Grand Court in 1976. Over 1,300 celebrities made appearances at Wanamaker's during Wetherill's tenure as director of public relations. *Courtesy of the Temple University Libraries, Urban Archives, Philadelphia, Pennsylvania.*

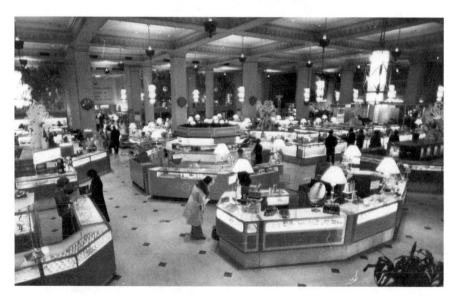

A view of the cosmetics department on the Chestnut Street side of the store. *Courtesy of the Temple University Libraries, Urban Archives, Philadelphia, Pennsylvania.*

Cashing Out

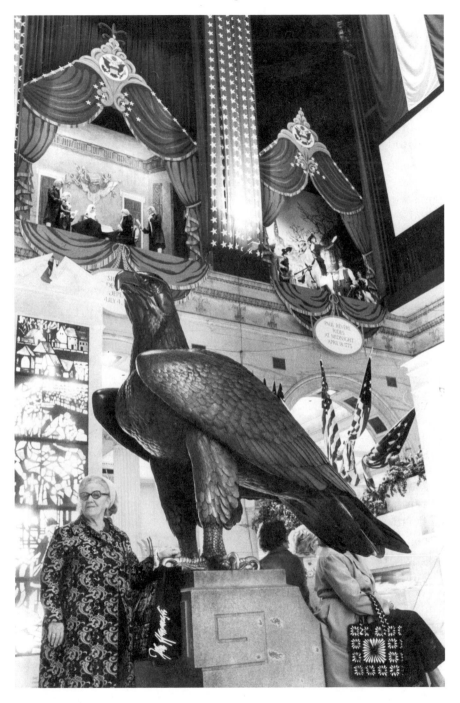

A woman waits at the Eagle as the store helps celebrate the country's bicentennial in 1976.
Courtesy of the Temple University Libraries, Urban Archives, Philadelphia, Pennsylvania.

breathe new life into the store. That plan was never initiated. Lits closed its eleven stores shortly after Easter 1977, leaving a large vacant hole on the eastern end of Market Street.

Lits' closing came at an interesting time for Philadelphia shopping, especially in Center City. The Gallery indoor shopping mall, along with the brand-new Gimbels store, was nearing completion. Wanamaker's, along with Strawbridge's and Gimbels, openly mourned the loss of Lits. However, the stores also looked forward to taking over Lits' share of the department-store business. Although discount store traffic increased, the other department stores never received a significant increase in sales. "When Lit Brothers closed, everybody was talking how we [Wanamaker's] were going to carve up that business amongst the other department stores and it just didn't happen," says Wanamaker family member and buyer Christopher Kellogg. "It just disappeared. It was a very strange thing."

On August 11, 1977, the Gallery opened for business to throngs of curious shoppers. Gimbels celebrated the move into its new headquarters. The old flagship, dating from 1894, was shabby and rundown. The night before the new Gimbels opened, management and store employees celebrated the old store's legacy with a champagne toast. The new Gimbels store strengthened the company's image as a worthy competitor to Wanamaker's and Strawbridge's. The new store gave Gimbels a glitzy shopping space filled with art, chrome and glass fixtures. But it lacked a clear architectural identity that gave downtown department stores their niche in their communities.

Wanamaker's was a business with loyal longtime employees. It was a company that relied on its history and traditions for its success. "It was an insular institution that didn't have any concern about Lits or Strawbridge's. The store management did its own thing and thought it was the right thing," says Christopher Kellogg.

The board of trustees brought Richard Bond back to Wanamaker's to help run the store. Wanamaker family and management were concerned about aggressive out-of-town merchants like Bamberger's, who were strengthening their position in the Philadelphia market. With Bond at the helm, Wanamaker's continued to open new stores. In 1978, stores at the Montgomery Mall and at the Lehigh Valley Mall, near Allentown, opened for business. Bond said that he was interested in sharpening the company's image and making future branch development, like the Lehigh Valley store, more innovative in design. However, behind the scenes, Bond was brought in to organize the sale of the business.

Cashing Out

The family was not as dedicated to continuing the business. "The family was not interested in continuing to run John Wanamaker's at all," says Professor Mercia Grassi. The stores needed upgrading and profits were declining. "The [Wanamaker] family felt that it didn't want to turn into Gimbels and go down to nothing," says Kellogg. John R. Wanamaker was the only family member who seemed interested in continuing with the store. "John was trying very hard to hold the company together," says John's wife, Louise Wanamaker. "He didn't want to sell it or disperse it. But after it was done he realized that it was the best thing for the store. The time had come," says Wanamaker.

Bond encouraged Carter Hawley Hale to purchase Wanamaker's for $45 million in cash and treasury stock. Carter Hawley Hale was the largest department store chain in the West. It operated some well-known department store names such as the Broadway, Emporium, Capwell's and Weinstock's. It also owned Neiman-Marcus and Bergdorf Goodman. Wanamaker's was Carter Hawley Hale's first traditional department store operation on the East Coast. Some family members were quick to accept Carter Hawley Hale's offer but some felt that the purchase price was not high enough. It created a huge rift within the family. "It was a very dramatic time and very unfortunate things happened," says family member Christopher Kellogg. Kellogg says that his interest was to turn the store around but the elder family members "were concerned about the long-term future of regular department stores." He also felt that the purchase price was too low. Kellogg, along with some other Wanamaker family members, contacted Angelo Arena, chairman of Chicago's Marshall Field. They convinced Arena to make an offer of $50 million in cash. After a heated bidding war on March 8, 1978, Carter Hawley Hale prevailed with an offer of $60 million in cash for Wanamaker's. After 117 years, Wanamaker's was no longer a Philadelphia corporation. The nation's largest privately held retail business was now in the hands of a West Coast firm.

Becoming an Albatross

I was very taken with such things as the organ and the Christmas show and the feeling that people had for Wanamaker's. But it turned out that it was more difficult to have it translate into "I'm going to shop there."
—*Richard P. Hauser, former president, Wanamaker's*

Carter Hawley Hale's purchase of Wanamaker's ended local control of the retail business. It ended the control by the seven-member board of trustees. The company lost business to stores like Bamberger's and Strawbridge's, and its stores desperately needed upgrading. Even Gimbels, with its new glitzy store in Center City, began to make a dent in its sales figures.

Carter Hawley Hale's first order of business was to upgrade the stores. The company prepared to spend $30 million over the next five years on renovations. "Everyone at Carter Hawley Hale knew that there had not been a lot of capital spent on the stores up to date and it was something we were going to have to do," says former president Richard P. Hauser. At the time, company officials stated, "In five years, we want to make it the best department store chain in the area."[86] Wanamaker's decided to concentrate its initial improvement efforts on the Center City store.

By the early 1980s, more out-of-town department stores took root in Philadelphia. Bloomingdales and Abraham and Straus opened stores in new retail centers in King of Prussia and Willow Grove. Even B. Altman added a second Philadelphia area store in Willow Grove. The major retailers from New York that came to Philadelphia seemed better at retailing than either

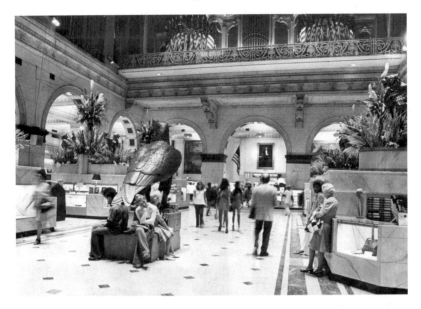

Waiting at the Eagle in May 1978. *Courtesy of the Temple University Libraries, Urban Archives, Philadelphia, Pennsylvania.*

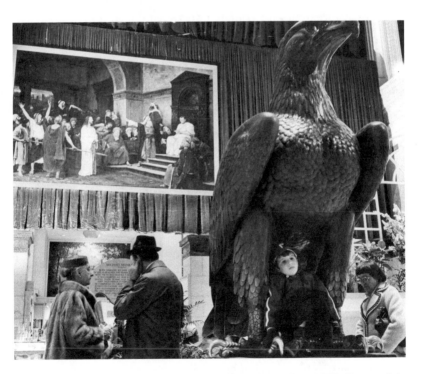

The Munkácsy paintings continued to be displayed during Lent 1979. *Courtesy of the Temple University Libraries, Urban Archives, Philadelphia, Pennsylvania.*

Wanamaker's or Strawbridge & Clothier. Former president Richard P. Hauser says "my effort was to bring Wanamaker's into the late twentieth century. It was hard to do because the customers were entranced by Bamberger's, Saks Fifth Avenue, Bloomingdale's and Lord & Taylor." Wanamaker's was not a money-maker when Hauser arrived. It was profitable but "it was not up to the standards that a good retail company expected." When he arrived, Hauser was puzzled that Wanamaker's did not seem to have its branch stores in the destination malls. "I wondered why Strawbridge branches were in better malls than Wanamaker branches," says Hauser. "I was told that Wanamaker's didn't want to be in the same malls as Strawbridge & Clothier. We ended up in secondary malls, which made it very difficult."[87]

Wanamaker's began upgrading the merchandise offerings, especially in the Center City store. The Tribout shop, the store's elegant salon, received a full makeover. "The Tribout Shop didn't have any rivals in the Philadelphia area," says Professor Mercia Grassi. "Nan Duskin was its closest competitor." Wanamaker's also began to promote new in-store designer salons, featuring names such as Cartier and Gucci. Even as the store introduced higher end merchandise, Wanamaker's continued to offer its traditional line of Rittenhouse Sportswear and Wanalyn dresses and coats.

Wanamaker's signature Tribout Shop in 1981. *Courtesy of the author.*

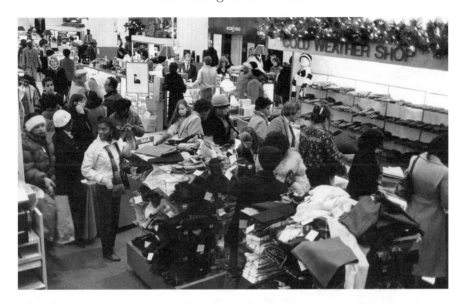

Last-minute shopping at the Center City Wanamaker's on Christmas Eve 1981. *Courtesy of the Temple University Libraries, Urban Archives, Philadelphia, Pennsylvania.*

The Crystal Tea Room, Wanamaker's signature dining room, began to serve new food selections, from frittatas to snow pea pods at the restaurant's salad buffet. But it continued to serve tea sandwiches to "ubiquitous, frosty haired ladies" that made lunch at Wanamaker's a daily, social ritual. In a 1982 interview, Wanamaker's vice president of food services, John O'Donnell, said, "I think if I took tea sandwiches off the menu they'd hang me by Billy Penn's hat."[88] Wanamaker's could not afford to alienate its traditional customer. The restaurant turned an extremely modest profit. "It's very difficult to make money at a restaurant that serves one meal a day and no booze," says Richard P. Hauser. The store prided itself on its traditional Philadelphia merchant reputation, and the Crystal Tea Room was one of Wanamaker's many signature traditions.

In March 1983, family member Francis Kellogg purchased the remaining 50 percent ownership of the New York Liberty Street Wanamaker's from Carter Hawley Hale. Carter Hawley Hale never paid much attention to the store. Kellogg said that since the Liberty Street operation was so small compared with the other Wanamaker's branches, Carter Hawley Hale management referred to it as a "twig" in the sixteen-store chain.[89] After he purchased Carter Hawley Hale's 50 percent ownership, Kellogg was allowed to still call the store John Wanamaker Liberty Street. Within a few months,

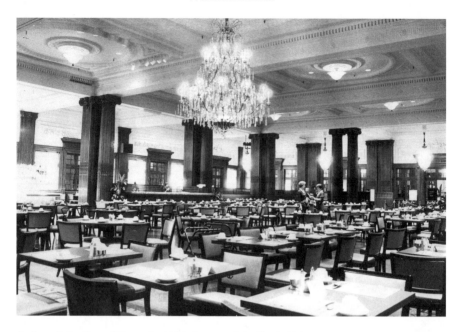

A view of the Crystal Room in 1981. *Courtesy of the Temple University Libraries, Urban Archives, Philadelphia, Pennsylvania.*

however, a rent increase made it impossible for the business to continue. Kellogg began to liquidate the Liberty Street store in August 1983. The move terminated one hundred jobs and ended almost eighty years of trade for the Wanamaker name in Manhattan.

Down Market Street, the privately held Strawbridge & Clothier battled a hostile takeover attempt. Members of the Strawbridge and Clothier families were the stockholders of the business. In 1983, New York investor Ronald Baron courted one Strawbridge family member's stock interest. Over the next few years, Baron tried to acquire Strawbridge & Clothier while devoted family members urged their relatives not to sell. Baron never gained control of Strawbridge's but it tested the loyalty of one of America's last family-run department stores.

Strawbridge & Clothier became Philadelphia's leading department store while Wanamaker's desperately tried to find its footing. Hauser upgraded the store's merchandise and image but it happened too quickly for its loyal shoppers and employees.

An article in the April 1989 issue of *Philadelphia Magazine* stated:

> *The message meant trouble from the tradition-bound staff, especially the buyers and merchandisers who didn't like to be told what to do. Like most*

A souvenir tin of the John Wanamaker Center City store from 1986. *Photo by Christian Colberg. Courtesy of the author.*

> *old-time department stores, Wanamakers had always been a middle-of-the-road kind of place—never so déclassé as to scare away the carriage trade. For more than a century, Wanamakers had made its money, and its reputation, by being everything to everyone.*[90]

Turning Wanamaker's around proved more difficult than Carter Hawley Hale originally thought. The upper management of Carter Hawley Hale grew frustrated with Wanamaker's. The stores urgently needed renovations. The merchandise mix confused the customers, and its market share continued to slide.

Like Strawbridge & Clothier, Carter Hawley Hale was the victim of a hostile takeover attempt. Owners of the Limited tried to purchase large quantities of Carter Hawley Hale's undervalued stock. Carter Hawley Hale was a publicly traded company and attempts were made to block the sale. Carter Hawley Hale tried to raise the value of its stock. The company consolidated many of the operational functions at each of its divisions. Professor Mercia Grassi says, "In order to save money, they began central buying. But Carter

Hawley Hale had no idea what the East Coast's customers wanted." Cutting costs at Carter Hawley Hale was simply not enough to raise the value of the company. Carter Hawley Hale had to shed some of its liabilities and the first place the company looked was Wanamaker's. At the time, Carter Hawley Hale vice president for corporate affairs Bill Dombrowski said, "We did not need a division of the company that was not paying its way. The Limited made their offer and our world changed. Wanamakers was obviously going to require a lot more capital. And frankly, we didn't have the capital."[91]

A FINAL FLIGHT

The renovation of the store was a Herculean attempt to attract shoppers to Center City and make Wanamaker's a destination.
—Arnold H. Aronson, former chairman, Woodward & Lothrop–John Wanamaker

The year 1986 was a tumultuous one for Philadelphia's local department stores. Strawbridge & Clothier continued to battle its hostile takeover attempt; Wanamaker's continued to post disappointing sales figures. But the major casualty of the year was Gimbels.

In January 1986, the owners of Gimbels put the stores up for sale. Department stores were attacked by high-end boutiques on one end and discount stores on the other. Over the years, Gimbels got caught in the middle and lost its identity. Department stores were expensive to run and Gimbels's stores were dated. Gimbels's ten Philadelphia locations were part of a nationwide network that included thirty-six stores in New York, Pittsburgh and Milwaukee. Only the Milwaukee stores and random New York locations were strong performers. Everywhere else, they struggled. Professor Mercia Grassi says that over the years, Gimbels lost its reputation and the stores lacked quality merchandise. "You didn't expect anything unique at Gimbels," says Grassi. Former Wanamaker's president Richard Hauser recalls that Gimbels was not an interesting place to shop. Hauser says, "They characterized their customer such that price was the only thing that mattered and nobody had good taste."

With no interested buyers, Gimbels began to close its stores across the country in June 1986. However, seven Philadelphia-area Gimbels were

purchased by Stern's, a Paramus, New Jersey-based unit of Allied Stores. Stern's promised $42 million over the next three years for renovations of the neglected stores; the renovations never occurred. Allied Stores became a takeover target, and the Stern's plan for its Philadelphia stores disintegrated. Its quiet presentation of nonthreatening merchandise fell flat. Mercia says the following about Stern's tenure in Philadelphia: "What was that about? What did Stern's represent? Philadelphia is not about to embrace you until you prove yourself here." In less than two years, Stern's was ready to pull out of the Philadelphia market—in February 1989, Stern's began to close the stores. The Center City and Echelon Mall stores were forced to remain open due to lease restrictions but they finally closed their doors in February 1992.[92]

Soon after the Gimbels names were removed from the stores, attention turned to Wanamaker's. In July 1986, Carter Hawley Hale put Wanamaker's up for sale. The future of Philadelphia's most famous retailing names was uncertain. The first company to bid on the stores was Hess's of Allentown, Pennsylvania. Hess's was famous for operating successful stores in smaller markets. It publicly shunned the notion of opening stores in major metropolitan markets but that changed with the potential purchase of Wanamaker's. Hess's submitted a bid of $80 million for the Wanamaker's stores. The bid fell overwhelmingly short of what Carter Hawley Hale wanted. Carter Hawley Hale also refused to accept an offer from Hess's because Hess's said it would immediately transform the Wanamaker's locations into Hess's stores.[93]

On November 4, 1986, Woodward & Lothrop purchased Wanamaker's. Known affectionately in its trading area as Woodies, Woodward & Lothrop was Washington's most famous traditional department store business. Real estate developer A. Alfred Taubman owned Woodward & Lothrop. The purchase seemed like a perfect marriage for both stores. "Woodies and Wanamaker's provided the same answers for equal clientele in each of their cities," says Mercia Grassi. Woodward & Lothrop paid $183 million for Wanamaker's. It beat out an offer made to Carter Hawley Hale by Wanamaker's management led by then president Richard Boje. Through the merger, the storied Wanamaker name was saved but thousands of Wanamaker management jobs were lost.

Wanamaker's was no longer a Philadelphia-based operation. Woodward & Lothrop's Washington staff was responsible for all operations of Wanamaker's. The biggest challenges that faced Woodies in Philadelphia were the intense competition for the department store shopper and the conditions of nearly all the Wanamaker stores. The branch stores were

never satisfactorily renovated under Carter Hawley Hale's leadership. In addition, the Center City store was too big for the amount of business that it was doing. Former president Richard P. Hauser says that Carter Hawley Hale felt that "had Wanamaker's started to close off selling floors in the Center City store, it would have had a deleterious effect on the reputation of the store."[94]

In May 1987, the Wanamaker's Globe Store in Scranton was sold to Globe management for $12 million. As the store's only acquisition, the Globe was an anomaly. Operating under its original name, the Globe Store had a loyal customer base in Scranton. The management of the Globe felt more time and money could be invested in the store than had been when Wanamaker's operated it. "The Globe could have used a face lift," says Hauser. "But it wasn't vital because there wasn't major competition at that point in Scranton." In the end, the cost of running a single department store caught up with Globe management. In January 1994, the doors of the Globe Store were suddenly shut and the life of a Scranton institution came to an end.

In October 1987, Woodward & Lothrop sold the Center City Wanamaker's building for $49.7 million. The sale conditions specified that the John Wanamaker store would lease the bottom five floors of the building and the remaining space would be converted into 840,000 square feet of office space. This paved the way for Woodies to reduce its commitment to the massive building. The following March, plans were announced for a $185 million renovation of the Center City structure. The plan was one of the costliest historic renovations in the country to date. Ironically, Woodies president Edwin Hoffman spearheaded the renovation. Hoffman was a controversial former president of Wanamaker's and was unceremoniously let go in 1968. Hoffman never expected to step foot in Wanamaker's again and now he was once again in control. Hoffman considered the building a diamond in the rough and called it "a monument to the greatest retailer who ever lived."[95]

As reconstruction began, the Crystal Tea Room was the store's first casualty. On December 31, 1988, the signature restaurant that had served elegant meals to generations of grandmothers and granddaughters in white gloves served its final meal.

Philadelphia Inquirer reporter Edgar Williams recalled,

> *There was an aura of poignancy. Clearly, the customers, largely grandmotherly, had come for auld lang syne, to reminisce, to take in the beauty of the crystal chandeliers and the dark, temple-height Ionic columns—and to partake of*

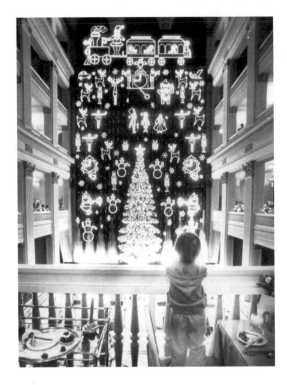

A child watches the Christmas Light Show from the store's third-floor Terrace Restaurant in 1987. *Photograph by Michael Mercanti. Courtesy of the* Philadelphia Daily News.

traditional Crystal Room specialties that ranged from tea sandwiches to rum raisin ice cream, with a lot of more substantial fare in between. As for the waitresses, they lived up to the definition of a professional: someone who does a job well regardless of whether he or she feels like it.

In the 1970s, the name of the restaurant was shortened to just the Crystal Room. Wanamaker's management wanted potential diners to know that the massive dining room served more than just tea. Unfortunately the name change was not enough to keep the restaurant alive after seventy-seven years of service. For Governor Ed Rendell, the saddest part of the store's downsizing was "losing the lunch room upstairs…They had the greatest waitresses. They were usually older ladies who had worked there for years and knew how to serve. They were proud of Wanamaker's and they were proud of the food."

As renovations continued, the department store industry was in chaos. Federated Department Stores and Allied Stores were aggressively taken over by Canadian real estate developer Robert Campeau; May Department Stores acquired Associated Dry Goods, parent of Lord & Taylor; and R.H. Macy

struggled financially. After all the mergers and takeovers, many stores were suffocated by their acquired debt. The industry continued to consolidate.

A. Alfred Taubman, Woodies's owner, grew impatient with his stores. Both Woodward & Lothrop and Wanamaker's faced increased competition and had many locations that were in need of major renovations. Instead of addressing the problems of the stores, Taubman put Woodward & Lothrop up for sale in September 1988, after only two years of ownership. But Taubman failed to attract interested parties. Marketing expert Kurt Barnard said, "The two [stores] are famous, well-established retail names, but there is no question that both of them require a great deal of overhaul. That takes time and, above all, money."[96]

The Woodward & Lothrop and John Wanamaker stores continued to experience sales declines. With no realistic offers in sight, Taubman made an about-face and decided to retain the stores and invest in their futures.

Construction continued, and plans to convert the Wanamaker building into a multiuse structure went forward. Taubman put Arnold Aronson in charge of the store. The rebirth of Wanamaker's was a tall order. Marketing expert Kurt Barnard said, "both Wanamaker's and Woodward & Lothrop are hallowed and revered institutions in their respective markets, but the problems they have suffered is that they have been relegated to the status of relics."[97] Aronson focused energy on the downsizing of the Center City store. "The renovation of the Center City store was done to help make the store more shopable and more modern," says Aronson. "The physical plant needed to be brought up to date, and the store needed to be laid out in a way that made more sense to the customer." Aronson hoped that the renovation would attract more shoppers to Center City and make the store a destination. "That store was so oversized for the amount of business that it was doing. It could absorb customers like a sponge," says Aronson. But Wanamaker's was still trying to play catch up with other retailers. In 1991, Kurt Barnard referred to Woodward & Lothrop and Wanamaker's as "two stores whose chances of survival are at best, slim."[98]

On September 26, 1991, the remade Center City Wanamaker building made its debut. The store consolidated its departments and upgraded its fixtures. The Eagle remained on its perch, and the organ graced the Grand Court. The famous organ survived the renovation but not without incident. During the downsizing, a workman accidentally hammered into a pipe, causing gallons of water to flow into the echo chamber. The Crystal Tea Room, the Piano Department, the Morgan Apothecary and many other touches that set the store apart from the competition were gone.

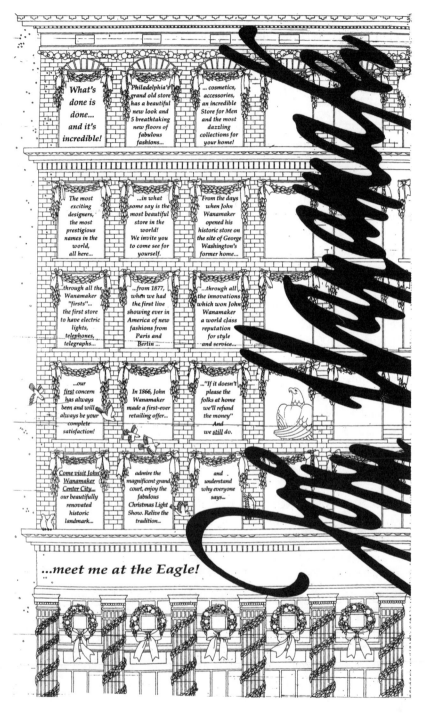

An advertisement of the Center City store's grand reopening in 1991. *Courtesy of the author.*

A Final Flight

Also in 1991, Wanamaker's opened a $22 million store at the Christiana Mall in Delaware, its first new store in more than twelve years. The Christiana Mall store replaced Wanamaker's longtime branch in the city of Wilmington. It also marked the very first time that John Wanamaker and Strawbridge & Clothier opened stores in the same mall. Like department store shopping trends, mall-shopping trends changed as well. Store loyalties waned and it didn't matter to Strawbridge's that its rival set up shop in a mall that it had anchored since 1978. A rival competitor was better than a vacant anchor store.

Debt load continued to crush Woodward & Lothrop. Woodies's owner, A. Alfred Taubman threw money into the business to keep it afloat, but by early January 1994 Taubman decided to stop making such contributions. Some people complained that a real estate developer like Taubman knew nothing about effectively running a department store business. Arnold Aronson disagrees. "Taubman undertook the major renovation of the Center City store. It was a huge investment. He kept it going as long as he could." On January 17, 1994, Woodward & Lothrop filed for Chapter 11 of the U.S. Bankruptcy Code. The company promised a swift reorganization. Instead, the company filed extension after extension, hoping to find some way to relieve itself of its massive debt.

The company's final branch store opened in 1991 at the Christiana Mall in Delaware. *Courtesy of the author.*

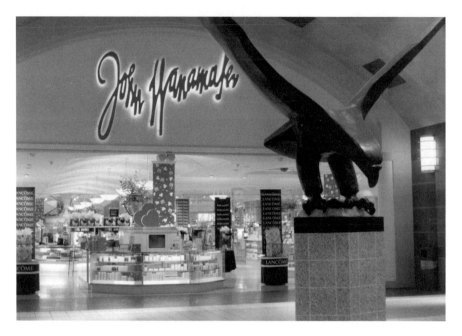

The mall entrance to the Christiana Mall store. *Courtesy of the author.*

At the time of the filing, Woodward & Lothrop had assets of $608.2 million and liabilities of $659.4 million. Chairman Arnold H. Aronson resigned after his bid to acquire Woodies was rejected by Taubman. Aronson stated that he had differences of opinion concerning how the company should move forward. The bankruptcy filing was not a surprise to industry experts. Many felt the filing was at least a year overdue. Though vendors were able to ship merchandise to the stores and have their payments guaranteed under the bankruptcy law, the store's troubles were far from over.

After a dismal Christmas 1994 selling season, store officials began the process of seeking buyers or winding down the business. The first casualty was the far-flung store in Yonkers, New York. In January 1995, Wanamaker's began a clearance sale at the Yonkers location. The Yonkers store had a loyal customer base and was the store's remaining presence in the New York area. The lease of the store was reassigned to Sears. After forty-one years of "dignified retailing," the Yonkers store closed the following March. That same March, Woodies stated intentions to close the once popular Jenkintown branch within the coming months.

The biggest news occurred on June 21, 1995. Woodward & Lothrop announced that its fleet of stores in the Philadelphia and Washington areas

The John Wanamaker logo displayed at the intersection of Thirteenth and Market Streets. *Courtesy of the author.*

The interior of the Center City men's department in 1995. *Courtesy of the author.*

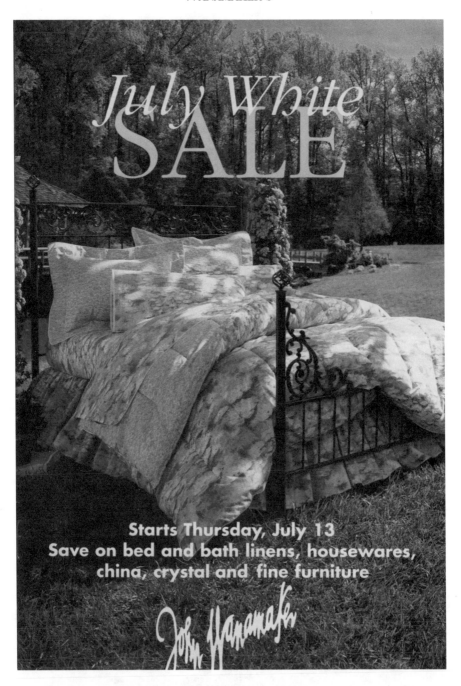

A circular of the store's final White Sale from July 1995. John Wanamaker invented the White Sale in 1878. *Courtesy of the author.*

would be sold to multiple owners. The *Philadelphia Inquirer* mourned that "John Wanamaker, a venerated name in Philadelphia retailing for more than a century, may be no more." In Philadelphia, the Wanamaker's stores were divided between Strawbridge & Clothier, Boscov's and Federated Department Stores. Federated would operate the Center City store as a Macy's outlet. Most Woodward & Lothrop stores would also be acquired by Federated but the flagship Woodies in downtown Washington was not part of the sale.

Immediately, memories and concerns about the stores came pouring in. What about the organ? What about the Eagle? What about the Christmas Light Show? But the loss of the name was too much for some to bear. One *Philadelphia Inquirer* asked, "What's in a name? A city's soul."[99] Concerned employees said, "Just the thought of them changing the John Wanamaker name—it does something to me. How could they? It'll always be Wanamakers." The loss of the Wanamaker name would be the loss of another piece of Philadelphia's identity.

Legendary Philadelphia city councilman W. Thacher Longstreth said:

> *Like most Philadelphians, I grew up in the great Center Room—the magnificent room with the organ. It's a loss of a great landmark and a sign of the times. People don't go for the service and the merchandise that characterized Wanamakers 40 or 50 years ago.*[100]

To many, Wanamaker's was an institution, "solid and inviolable—or so it always seemed."[101]

But efforts to control Woodward & Lothrop and John Wanamaker stores were not over. On July 27, 1995, May Department Stores entered a bid of $547 million for the stores; it operated Washington's Hecht Co. division. Though the bid was higher than Federated's, May's offer did not promise that the Center City Wanamaker's would remain open. As a bidding war ensued, it was learned that Federated would also not promise to operate the Center City store. On August 8, 1995, a bankruptcy judge awarded the stores to May Department Stores and J.C. Penney Co. The winning bid was $725 million. The Philadelphia stores were assigned to Washington's Hecht's division and Penney's took over most of Woodies's Washington stores. May promised to keep the Center City store open but it was the end of the Wanamaker name. The Wanamaker stores would be renamed Hecht's. Countless people poured into the Center City Wanamaker's looking for one last souvenir. In one final tip of the hat, the *Philadelphia Inquirer* printed a special inset in its August 28, 1995, newspaper simply titled "John Wanamaker, Philadelphia says Good-bye."

AFTERLIFE

There's an old saying that Wanamakers is Philadelphia's Second City Hall. The building is part of the fabric and the psyche of the city.
—Curt Mangel, curator of the Wanamaker organ

O n Sunday September 3, 1995, the former Wanamaker locations began trading as Hecht's stores. Hecht's was determined to become a major force in Philadelphia retailing. The former Wanamaker's stores were restocked and new "Hecht-style productive store fixtures" were brought in. Hecht's stores in other markets achieved almost twice the sales numbers as the former Wanamaker's stores. The company hoped to bring that same level of success to Philadelphia. Hecht's CEO Irwin Zazulia said, "When you walk into a Hecht's store, the geography, the look and the presentation, the signing will be consistent."[102] However, when one walked into the former Wanamaker's locations, one walked into stores that were in desperate need of attention. Hecht's initial plan of "tuning up" the appearance of the stores with modest painting was simply not enough.

Center City leaders were pleased that Hecht's appeared committed to the former flagship Wanamaker's store. Many feared that if the store closed, the Center City business district would be devastated. Hecht's had a reputation for offering middle-of-the-road merchandise in large selections at competitive prices. Business leaders were skeptical that Hecht's would draw people to Center City.[103]

Hecht's was determined to retain the Wanamaker's traditions. The organ music continued and the Eagle remained. Hecht's decked out the Center City

The former Christiana Mall Wanamaker's store operating as a Hecht's store in late 1995. *Courtesy of the author.*

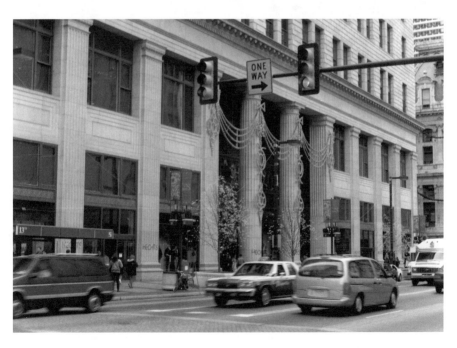

The Center City Hecht's store decorated for Christmas with traditional Wanamaker's decorations. *Courtesy of the author.*

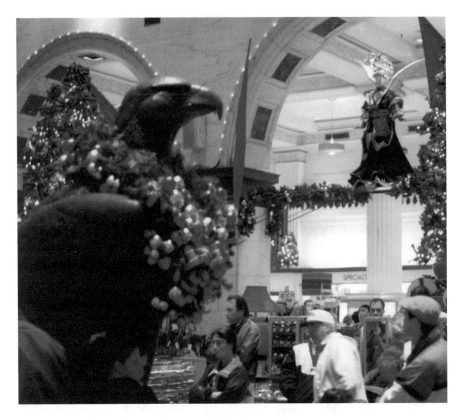

Hecht's lavishly decorated the Eagle for Christmas 1995. *Courtesy of the author.*

store at Christmastime with ornate decorations and presented the annual Christmas Light Show. A gift shop in the Grand Court displayed Christmas merchandise featuring The Christmas Light Show—A Hecht's Tradition.

After a dismal Christmas selling season, it was clear that Hecht's was not winning over Philadelphia shoppers. May Department Stores refused to give up on its Philadelphia investment. "Hecht's deserves a lot of credit for keeping it as an ongoing store," says Governor Ed Rendell, a former mayor of Philadelphia. "At one point, Hecht's wasn't sure that they were going to keep it open. They weren't sure the downtown store was viable." Store management worked hard to keep the Center City store alive. Many people felt that Hecht's erased too much history with the removal of the Wanamaker name. The conditions of the branch stores didn't help the image either. But with the Philadelphia store stumbling the company decided to erase some of its toughest competition, namely Strawbridge & Clothier.

Just about eight months after they purchased the Philadelphia John Wanamaker stores, May announced an agreement to purchase the 13 Strawbridge & Clothier stores. Hecht's Arlington, Virginia, headquarters would operate the newly acquired Strawbridge & Clothier stores and the recently acquired John Wanamaker stores as Strawbridge's. The executive offices of Strawbridge & Clothier would be closed and more than four thousand jobs would be eliminated. The Center City Hecht's store, as well as the former Wanamaker's store at the Christiana Mall in Delaware, would eventually become Lord & Taylor units. This was all subject to the approval of Strawbridge and Clothier family shareholders. Strawbridge & Clothier was still a family-run department store, one of the last of its kind in the country.

After a boardroom battle, Strawbridge & Clothier was officially sold to Hecht's on July 15, 1996. Strawbridge & Clothier was just as cherished to Philadelphia as Wanamaker's, and Philadelphians mourned the loss of yet another piece of their identity.

When Hecht's changed the name of the Wanamaker stores, it knowingly wiped away a large piece of Philadelphia history. It was not about to repeat the mistake with the Strawbridge & Clothier stores. After a brief period of

The former Oxford Valley Wanamaker's–Hecht's store operating as a Strawbridge's. *Courtesy of the author.*

restocking, Strawbridge & Clothier stores reopened, simply as Strawbridge's stores, and the Strawbridge's at Eighth and Market Streets opened its doors for business, minus the Strawbridge family. Hecht's was now the major department store in Philadelphia.

In an interesting move, Hecht's decided to rename the former Wanamaker flagship store Strawbridge's. After decades of intense competition, the Strawbridge name graced the doors of the Wanamaker building. There were now two Strawbridge's stores on Market Street, one at Eighth Street and one at Thirteenth Street. The former Wanamaker operation was only temporary since the location was set to become a Lord & Taylor store in 1997. Hecht management decided it could not afford to close the Thirteenth Street store and discontinue the Christmas Light Show, even for one year. To many the Thirteenth Street store was never considered a Strawbridge's—it was always the "old Wanamaker's."

Two Hecht's stores never made the transition to Strawbridge's. The former Wanamaker's in Jenkintown and the former Wanamaker's in Wynnewood failed to show satisfactory sales figures. Both were freestanding locations and both were the oldest of the former Wanamaker's stores. In the 1970s, Jenkintown was the company's highest grossing store; but by the 1990s, its performance was poor. Hecht's announced the closings two weeks apart from each other in May 1996. Another chapter of the Wanamaker saga ended.

SHOP FRIDAY 8 AM TO 10 PM, SATURDAY 8 AM TO 8 PM

STARTS TOMORROW

CENTER CITY
13TH & MARKET STREETS

CLOSING SALE

TAKE AN ADDITIONAL

30%OFF

THE LOWEST TICKETED PRICE ON EVERY ITEM IN THE STORE

strawbridge's

The former Center City Wanamaker's operated as a Strawbridge's for almost four months. In January 1997, Strawbridge's began a closing sale at the legendary Wanamaker's site, ending its life as a department store. *Courtesy of the author.*

On January 17, 1997, the "old Wanamaker's" began its final closing sale. Trading as a Strawbridge's, the store marked down all merchandise 30 percent. Over the next two weeks, the store's merchandise was gradually sold off, literally to the bare walls. The organ was silent and the mood in the store was somber. On its last day of operations, many Philadelphians came to pay their last respects. To them, it was still Wanamakers.

Maureen Graham of the *Philadelphia Inquirer* commented:

> *Had John Wanamaker been around to see it, chances are he would have been moved. Some teary eyed visitors actually talked to the bronze Wanamaker Eagle, which has graced the Grand Court. Others reminisced about days gone by, remembering shopping trips with their grandmothers and great-grandmothers...Though the name was changed to Hecht's and then Strawbridge's, many residents continued to call it Wanamakers—and to think of it as the same store that founder John Wanamaker once built into a powerhouse with his policy of guaranteed customer satisfaction.* [104]

The store closed its doors on February 1, 1997, for a seven-month conversion into a Lord & Taylor. Lord & Taylor was founded in New York in 1826 and is one of America's oldest retailers, operating as a specialty store, not a department store. Until the 1980s, Lord & Taylor had extensive home departments in their stores, but by the end of the 1980s, it began dealing almost exclusively in apparel and accessories. As previously announced, the new Lord & Taylor would occupy only the first three floors of the Wanamaker Building, using only 156,550 feet of selling space. It would still have the Eagle, and it would still have the organ. But it would be a new type of business. It was an opportunity for the Hecht's–Strawbridge's parent company, May Department Stores, to get a fresh start at the Wanamaker site.

> *Hecht's, which runs Strawbridge's, had to contend, twice, with the region's sadness and resentment at the loss of a treasured retailing institution—first John Wanamaker, then Strawbridge & Clothier. In the transition, Hecht's acquired merchandise from both retailers, blurring identities and making it difficult for shoppers to get a good fix on what they could expect from the new merchant in town.* [105]

On August 6, 1997, Lord & Taylor opened its brand new store in the former Wanamaker's location in Center City. Six hundred guests came to celebrate. Visitors were serenaded by the Wanamaker's organ, which

The Lord & Taylor signature logo displayed at the intersection of Thirteenth and Market Streets. *Courtesy of the author.*

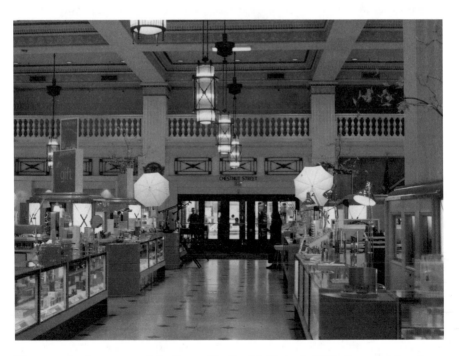

The cosmetics department of the Center City Lord & Taylor in 2005. *Courtesy of the author.*

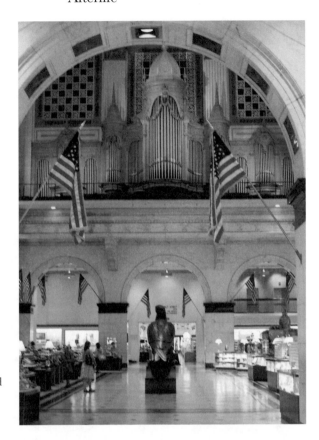

The Grand Court at Lord & Taylor decorated with American flags in 2005. *Courtesy of the author.*

performed *Everything's Coming Up Roses* for the crowd. It was a fresh start for the building, but the organ, the Eagle and a commitment to the Christmas Light Show remained. For years, Lord & Taylor promoted the clothing of American designers in their stores. Each store was adorned with American flags and every shopping day began with a recording of the *Star-Spangled Banner*. The same was true for the Center City store. Lord & Taylor also featured a simple red rose in much of their advertising. It was part of Lord & Taylor's identity.

In addition, Lord & Taylor restocked the store with its own, fresh merchandise. With the upper-end, large retailer in Center City, Philadelphia city officials hoped the new Lord & Taylor would help stabilize the business district.[106]

Lord & Taylor faced continued challenges with the Center City store. Without a home department, Lord & Taylor was dismissed as a true department store. Its immediate surroundings did not draw an upper-

end clientele. By 1999, Lord & Taylor publicly stated that the Center City store was not profitable. Lord & Taylor president Clarence O. Reynolds reassured customers and residents that the company was not going to abandon the location. "Being in the Philadelphia market is very important to us," Reynolds said. "There are a lot of things we can do in this store to make a statement about Lord & Taylor's. I think it is important that we support the tradition of the city and that we carry on the tradition that Wanamaker started."

For the next several years, Lord & Taylor kept a relatively low profile at the Center City store. The store continued to employ organists and support staff for the Wanamaker's organ. In regard to the organ, "Lord & Taylor came through when they needed to," says Ray Biswanger of the Friends of the Wanamaker Organ. Every year, the store still presented the annual

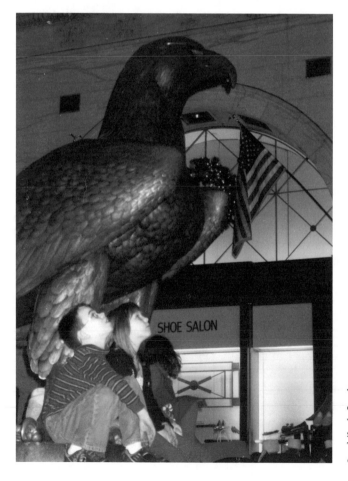

The author's daughter, Jordan, watching the light show at Lord & Taylor in 2005. *Courtesy of the author.*

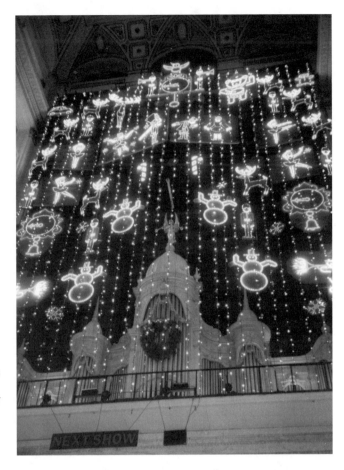

By the early 2000s, the Magic Christmas Tree and Santa's train were noticeably missing from the Christmas Light Show. *Courtesy of the author.*

Christmas Light Show. However the display was becoming more and more fragile every year. Soon, the Magic Christmas Tree and Santa's train had to be retired and the show was drastically shortened. The aging electrical system only allowed the show to be presented every other hour during the Christmas season. After the September 11 attacks occurred in 2001, Lord & Taylor ended the show with the *Star-Spangled Banner* and the unraveling of a four-story American flag.

The department store world was forever changed in March 2005 when Federated Department Stores announced they had reached an agreement to acquire May Department Stores. Federated was the operator of Macy's stores throughout the country and May Department Stores was the owner of Strawbridge's. Federated sought to make Macy's a nationwide chain of department stores and had just converted Miami's Burdines, Atlanta's

Rich's, Memphis's Goldsmith's, and Columbus's Lazarus stores into the Macy's nameplate. Federated's purchase of May stores signaled the likely end of the Strawbridge name in Philadelphia.

May Department Stores was also the parent company of Lord & Taylor. It was unclear what Federated's intentions were for Lord & Taylor. Federated kept quiet about Lord & Taylor's future but openly stated that it would transform all of May's regional department stores to the Macy's nameplate. Names like Filene's, Famous-Barr, Kaufmann's, L.S. Ayres, Hecht's and Strawbridge's would be converted to Macy's in 2006. After some analysis, Federated decided to go ahead and change Chicago's Marshall Field's stores to the Macy's nameplate. That proved to be an unpopular move. Dozens of department stores across the country closed their doors where Federated and May each had locations. But with Federated's purchase of Strawbridge's and Lord & Taylor, the future of department stores on Philadelphia's Market Street remained uncertain.

Finally, on January 30, 2006, Federated announced that it was selling the Lord & Taylor division. The company was only interested in operating Macy's and Bloomingdale's locations. On March 11, 2006, Federated decided to turn the Center City Lord & Taylor store into a Macy's. Down at Eighth and Market Streets, the landmark Strawbridge's store prepared for its closure. In regard to the new Macy's location, Federated officials wanted to reassure the public that Macy's would protect the Wanamaker organ and Eagle. By June 2006, the Center City Lord & Taylor doors were closed.

Macy's finally had a Center City location. On August 2, 2006, the former Center City Wanamaker's opened for business as a Macy's. It was the fifth name for the store in eleven years. The store celebrated its reopening with great fanfare. For almost ten weeks, Center City Philadelphia had been without a department store. The new Macy's still only occupied the first three floors of the Wanamaker building. The location did not include a home department and, after an initial outcry, one was added a few years later.

Macy's was committed to many of the Wanamaker traditions. The Eagle remained and so did the organ. Ray Biswanger of the Friends of the Wanamaker Organ applauded Macy's commitment to the famous organ. "Macy's is in the parade business and the organ is part of their business plan," says Biswanger. After years of wear and tear, the equipment of the Christmas Light Show was practically rebuilt. Macy's refurbished the Magic Christmas Tree and replaced the lights with new LED light bulbs. All of the restoration helped to assure Philadelphians that the company was determined to maintain the building's hallowed traditions.

In August 2006, Macy's opened a location on the bottom three floors of the Wanamaker building. Pictured is a street scene from December 2009. *Courtesy of Matthew Truch.*

On Saturday, September 27, 2008, Macy's celebrated its 150th anniversary in true Wanamaker fashion. Organist Peter Richard Conte joined the Philadelphia Orchestra, under the direction of Rossen Milanov, for a concert in the store's Grand Court. The centerpiece of the evening was a performance of Joseph Jongen's Symphonie Concertante. Specifically intended for the Wanamaker organ, Rodman Wanamaker commissioned Jongen's work in 1926. However, the premiere performance at the Wanamaker store was postponed, due to delays involving work on the organ and Rodman's untimely death. The Symphonie Concertante was given its American premiere at Carnegie Hall in 1935, but it took 73 years for the work to be performed by the instrument for which it was originally commissioned. Peter Richard Conte addressed the twelve hundred audience members and reminded them that the performance of Jongen's composition was "history in the making." Proceeds from the performance benefited the Friends of the Wanamaker Organ.

Philadelphians have had a difficult time knowing what exactly to call the building. Philadelphia never accepted the name Hecht's or the name Lord & Taylor. Even when the store transformed into the Macy's nameplate, many Philadelphians still called the store Wanamaker's. For most people, it will always be Wanamaker's. Regardless of the name on the door, Philadelphia will always cherish the opportunity to hear the world's largest playing pipe organ, see a four story Christmas Light Show and meet each other at the Eagle.

Courtesy, Integrity, Mutuality

The Wanamaker Building stands today not just as an architectural icon but as an active reminder of how Philadelphia's thriving downtown began.
—Michael A. Nutter, mayor of Philadelphia

In 2011, the Wanamaker Building will celebrate its one hundredth anniversary. The building still plays an important role in the daily lives of many Philadelphians. But the building plays an even more important role in the memories of many people who came to the building to shop, work or meet up with one another.

City Councilman Frank Rizzo Jr. remembers that Wanamaker's "was a very, very special place to shop for very, very special occasions." Rizzo recalls that when he "got a gift from Wanamaker's, [he] knew that it was going to be a special gift. And…it always was." Pat Ciarrocchi agrees. "Any gift—any special gift—you went to Wanamaker's to get it." For Trudy Haynes, Wanamaker's was the epitome of class. "Wanamaker's was a store that people enjoyed going to because it was a very pretty store. It was a very up-class store that made you feel pretty when you went into it to shop," says Haynes.

Sally Starr's first credit card came from Wanamaker's. "I'd tell my husband, Jesse, that I'm going over to Wanamaker's. I'd come back and he'd say 'Sally, what did you do!'" says Sally. For her, it was the merchandise and service that helped make Wanamaker's stand apart from the competition. "Wanamaker's was a high-end store with good bargains and good merchandise. But most importantly, Wanamaker's stood behind their merchandise."

Lynne Abraham took the Number Forty-two trolley with her grandmother for special shopping trips to Wanamaker's. She equates a trip to Wanamaker's "like taking a trip to Valhalla." "It was so imposing and impressive as a kid," says Abraham. Joel Spivak also enjoyed his trolley trips to Wanamaker's and fondly recalls the grandeur of the Grand Court. "I loved going down there because you could look down and see the big organ. It was really great when the organ was playing," says Spivak. The store was mammoth in size but every floor offered something different and unique. Spivak says that Wanamaker's was special because "each floor had its own environment."

Pennsylvania governor Ed Rendell says that Wanamaker's was more than just a convenient place to meet. "It was fun because there was always a lot of activity," says Governor Rendell. "There was so much about the old Wanamaker's that made it a special place, including the Christmas Show, the organ and the Eagle." But probably his favorite memories are of his son, Jesse, enjoying breakfasts with Santa, the Easter Bunny and Mickey Mouse. For Governor Rendell and his family, Wanamaker's was full of entertainment and fun. "It was just a spectacular place." Mayor Michael Nutter admires the role that the Wanamaker's store and the Wanamaker building played in the lives of many Philadelphians. "In Philadelphia's great history as a 'city of firsts', the Wanamaker Building succeeded not just as an innovative kind of retail center but as a central destination and meeting place for citizens across the city," says Mayor Nutter.

As the curator of the Great Wanamaker organ, Curt Mangel praises the building's current tenant for the respect it shows for "without question, the most famous organ in the world." "Macy's has been the best operator of the organ since Rodman [Wanamaker] passed away in 1928," says Mangel. Even though the store has been reduced to only three selling floors, Mangel says, "the current organ suits the space acoustically."

For Mercia Grassi, working at Wanamaker's was a dream come true. "I had already made up my mind at age five or six that I was going to work there. I thought that working there was [going to be] so very glamorous," says Grassi. One of her earliest jobs at Wanamaker's was serving on the store's Teen Board. "We did informal modeling in the Crystal Tea Room on Saturdays at lunchtime. You would go from table to table showing off what you were wearing. You would stop at each table, twirl around and describe what you had on. You ended up selling it and you got experience in selling," says Grassi. Most importantly, Wanamaker's was an important employer of women. Grassi explains that "there was no other industry where a woman was a top notch executive, but there they were at Wanamaker's. And that's what helped attract me [to retail]."

Richard Hauser says that the strong feeling that people had for local retailers disappeared as people became older. "But Wanamaker's was just as beloved in Philadelphia as Marshall Field was in Chicago," says Hauser. Author Richard Longstreth continues the comparison of the Wanamaker's legacy to that of Marshall Field's. "Both Wanamaker's and Field's had been industry pioneers, had played a major role in recasting the department store as a palatial emporium at the turn of the century, continued to be national leaders, were the largest stores in their respective cities and purveyed the most stylish merchandise," says Longstreth.[107]

William Zulker was impressed with John Wanamaker as a person. Zulker spent months helping to organize Wanamaker's papers for the Historical Society of Pennsylvania. "When I was given the first box, I sat there with tears rolling down my cheeks. I was thinking of the compassion and love within this family, between the father, the mother and the children. It was just fantastic to me," says Zulker. He believes that the secret to John's success was his personality and his deep religious faith.

Retail historian Bruce Kopytek recalls a visit he paid to Wanamaker's in the late 1980s. The store was just beginning to be converted into a partial office building but Wanamaker's still made a lasting impression on him. "It seemed beautiful, immaculate and so full of class and culture," says Kopytek. He returned about twenty-five years later but the store was no match from what he remembered. "The shuttered Strawbridge & Clothier or the eternal parking lot where Gimbels once stood did nothing to lighten my mood," states Kopytek.

Herbert Ershkowitz notes that Macy's is the last department store in Center City. He wonders about the future of department stores, in general. "I've walked around Macy's and there's nobody in there. It really bothers me. I wonder, how long is it going to stay there?" says Ershkowitz. He recalls that it was even worse when it was Lord & Taylor. "I knew Lord & Taylor was not going to make it," says Ershkowitz.

Peter Richard Conte says it is an "honor and a privilege" to be the Grand Court organist of the Wanamaker Organ. He refers to the organ as "the most symphonic musical instrument in the world" as well as "the pinnacle of the symphonic school of organ building." Conte and his three assistants perform on the organ twice daily except Sunday. "If I'm in town, I'm here," says Conte. "It's a great gig!" In 2010, a restored Wurlitzer organ was placed in the building's Greek Hall. "To have a retail establishment [Macy's] adding organs to their stores in this environment is unbelievable. I just love it!" declares Conte. If the Liberty Bell is the "heart of Philadelphia," as the saying goes, then the Wanamaker Organ is the voice of Philadelphia.[108]

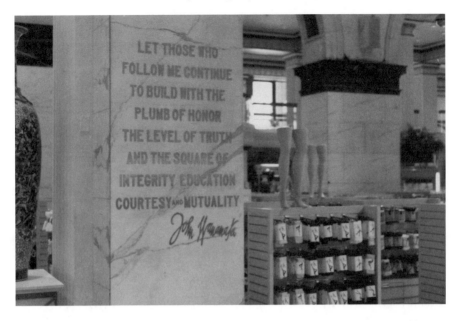

The Grand Court still proudly displays the words that John Wanamaker followed in his personal and business lives. The words are rumored to be John Wanamaker's final message to his associates. These same words are also inscribed on the famous Founder's Bell, high atop Center City. *Courtesy of the author.*

But the problem that many Philadelphians have is "what do you call the store?" Since 1995, the name on the building has changed many times over. It can be difficult for a lifelong resident to adapt to a name on the building other than Wanamaker's. Lynne Abraham doesn't even know what it is called now. "To me, it will always be Wanamaker's." Pat Ciarrocchi calls it the "old Wanamaker's." "For that store, there isn't any other identity than the 'old Wanamaker's,'" says Ciarrocchi. "If you're from Philadelphia, if you have any history in this city, you just call it the 'old Wanamaker's.'"

From the Crystal Tea Room

Fruit Salad Hawaiian with Grenadine Dressing[109]

1 whole fresh pineapple
Orange sections
Grapefruit sections
Melon balls
Grapes
Strawberries
Mayonnaise dressing
Grenadine

Cut the pineapple in half, lengthwise. Do not remove the green. Scoop out all pineapple pulp with a vegetable scoop, leaving the shell. Fill the shell with pineapple balls, orange and grapefruit sections and melon balls. Decorate with grapes and fresh strawberries. Add 1 tablespoon of grenadine to every cup of mayonnaise. Serve with mayonnaise dressing.

Vegetable Soup

1 cup carrots
1/2 cup onions, diced
1 stalk celery, diced
1 clove garlic, finely chopped
2 teaspoons oil
1 tablespoon flour
2 cups stewed tomatoes
1/2 cup tomato puree
1-1/2 cup string beans, cut into pieces
3 beef bouillon cubes
1 quart water
1 pinch basil
1 tablespoon Worcestershire sauce
1 tablespoon barley

Saute the carrots, onions, celery and garlic with oil in a pot for three minutes.
Add 1 tablespoon flour and mix well. Add tomatoes, puree, beans, bouillon
cubes, water, basil, Worcestershire sauce and barley. Simmer for 30 minutes.
Serves 6.

Cheese Pie

1/2 pint cream
1/2 pint milk
4 eggs, beaten
1/2 pound grated Swiss cheese
1 pinch paprika
Salt, to taste
Pastry for tart shells

Combine the eggs, milk, cream and cheese. Add paprika and salt. Mix and
fill tart shells. Bake in 450 degree oven for 10 to 12 minutes. Serve hot as
luncheon appetizer or as the main course, with a mixed green salad.

Appetizers, Soups and Consommes

Clam Juice Cocktail	25	Fruit Supreme	25
Honeydew Melon	35	Shrimp Cocktail	30
Cherrystone Clams (6)	35	Little Neck Clams	30
Tomato Juice Cocktail	15	Crabmeat Cocktail Olympic	50
Blue Point Oysters	35	Robbins Island Oysters	35

Half Grapefruit 15

Old Fashioned Lentil Soup	15	Vegetable Soup	15
Chicken Broth with Rice	15	Minced Clam or Oyster Stew	55

(Tureen or Soup 40c)

Luncheon Platter Suggestions

(The Price Includes Roll and Butter, Dessert and Coffee)
(Tomato Juice or Cup of Soup May be Substituted for Dessert)

FRIED NEW ENGLAND CLAMS, Stuffed Baked Potato, Chef's Salad 75

TUREEN OF LENTIL SOUP, HAM and SWISS CHEESE SANDWICHES 85

SWISS STEAK with Glaced Carrots, Peas, Mashed Potatoes 95

SWEETBREAD CUTLET, Creamed Mushroom Sauce, New Peas,
Candied Sweet Potato 95

ASSORTED COLD CUTS with CHICKEN, Potato Salad 1.00

BLUEFISH MEUNIERE, French Fried Egg Plant, Peas, Grilled Tomato 1.15

CHICKEN A LA KING with Waffle, New Peas 1.25

ROAST LEG OF SPRING LAMB, New Peas, New Rissole Potato 1.25

SEA FOOD GRILL with CASSEROLETTE OF LOBSTER MORNAY, Chef's Salad 1.35

Chocolate, Vanilla, Coffee, Strawberry, Rum Raisin or Burnt Almond Ice Cream

Raspberry Sherbet Orange Ice Rice Pudding Plum Compote

Stewed Rhubarb Cheese Pie Rhubarb Pie Apricot Pie Huckleberry Pie

Coffee, Tea or Fruit Lemonade

Co-opera
the Gov
War

All of
Rolls, Bu
RICHED
important
of The
Complex
Vitamin

Desserts

Rhubarb Pie	15	Cream Puff with Whipped Cream Filling	15
Apricot Pie 15 Cheese Pie 15		Angel Cake	15
Stewed Fresh Rhubarb	15	Chocolate Layer Cake	15
Plum Compote	15	Rice Pudding	15
Apple Pie	15	Cup Custard	15
STRAWBERRY TART	25	ORANGE ICE	15
STRAWBERRY COUPE	25		

Chocolate, Vanilla, Coffee, Strawberry, Rum Raisin or Burnt Almond Ice Cream 15

Beverages

Coffee, Per Cup	10	Iced Coffee	15
Milk, Buttermilk or Chocolate Milk	10	Tea (Hot or Iced)	15

FRUIT LEMONADE 15

This page and next: The Crystal Tea Room menu from March 19, 1946.

Wanamaker's Shopper's Luncheon 65c

Philadelphia
19 marzo 1946

(Service 11:00 to 2:30)
(Cup of Soup May be Substituted for Dessert)

Choice of

ASSORTED COLD CUTS, Potato Salad
STEWED KIDNEYS BORDELAISE with Rice
FRESH VEGETABLE PLATTER
FRUIT SALAD and Brandied Mince Meat Muffin
WINDSOR SANDWICH (3 Layers) with Creamed Slaw
EGG GRAND DUC (Poached Egg, Sauce Mornay), Broccoli, Ragout of Mushrooms

Choice of

Chocolate, Vanilla, Coffee, Strawberry, Rum Raisin or Burnt Almond Ice Cream
Raspberry Sherbet Orange Ice Rice Pudding Plum Compote
Stewed Rhubarb Cheese Pie Rhubarb Pie Apricot Pie Huckleberry Pie

Coffee, Tea or Fruit Lemonade

NO SUBSTITUTIONS PLEASE!

g with
ment
fort

Bread,
are EN-
th two
members
min B
cluding
& Iron

Popular Combination Platters

(Price Includes Roll and Butter)

BONELESS BAKED SHAD, Crystal Tea Room, Cole Slaw	1.25
SHAD ROE MEUNIERE, Broccoli, New Potato, Cole Slaw	1.25
LOBSTER THERMIDOR with Saratoga Chips and Chef's Salad	1.50
FRIED OYSTERS, Red Slaw and Potato Salad	75
DEVILED CRAB, Cole Slaw and French Fried Potatoes	1.00
CHICKEN SALAD, FRIED OYSTERS and French Fried Potatoes	1.10
CHICKEN CHOW MEIN ORIENTAL	75

Cold Buffet

CRAB RAVIGOTTE, Hearts of Celery, Sliced Tomato	1.00
KENNEBEC SALMON CARDINAL, Sliced Tomato and Celery Salad	1.00
LOBSTER EXQUISITE, Saratoga Chips and Sliced Tomato	1.50
TOMATO STUFFED with CHICKEN SALAD, Egyptienne Sandwiches	1.10
SHRIMP SALAD GOURMET, Sliced Tomato and Saratoga Chips	1.00
HORS D'OEUVRES A LA FRANCAISE	1.00
FRUIT SALAD HAWAIIAN (In Half Pineapple) with Grenadine Dressing and Tea Sandwiches	95
SALAD BOWL—(A Combination of Fresh Cut Garden Salads) with Egyptienne Sandwiches	65

Salad and Sandwich Platters

Chicken Salad	1.00	Fresh Vegetable Salad	65
Lobster Salad	1.75	Tomato Stuffed with Deviled Egg, Egyptienne Sandwiches	65
Fruit Salad, Grenadine Dressing and Tea Sandwiches	65	Tomato Stuffed with Salmon Salad, Saratoga Chips	65
Half Alligator Pear Filled with Waldorf Salad, Tea Sandwiches	75	Baked Cheese on Toast, Cole Slaw	45
	Crab Meat Salad	75	

Sandwiches

Wanamaker Sandwich Platter	50	Ham Sandwich	40
Tomato and Lettuce	35	Windsor Sandwich (3 Layers)	40
Open Salmon Salad Sandwich	65	Club Sandwich	75
Chicken Salad Sandwich	75	Minced Chicken Sandwich	50
Tongue	40	Sliced Chicken Sandwich	65
Crabmeat and Lettuce Salad Sandwich	75		

TUESDAY, MARCH 19, 1946

EGGS WITH MORNAY SAUCE

6 hard boiled eggs
2 small onions, chopped fine
2 slices ham, chopped fine
6 medium mushrooms, chopped fine
Butter
2 tablespoons cream sauce
2 cups cheese sauce
Salt and pepper, to taste
Cheese

Hard boil the eggs, cut in half lengthwise and remove yolks. Saute the onions, ham and mushrooms in butter. Crush egg yolks with a fork and add them with the cream sauce to the onions, ham and mushrooms. Fill the egg whites and cover with cheese sauce. Sprinkle with cheese and bake in a 400 degree oven for 10 to 15 minutes, until thoroughly heated.

Notes

Starting a New Business

1. Wanamaker Papers, Historical Society of Pennsylvania, Philadelphia, Pennsylvania.
2. *Welcome to Philadelphia and John Wanamaker* (Philadelphia: John Wannamaker, 1947).
3. Herbert Ershkowitz, *John Wanamaker—Philadelphia Merchant* (Philadelphia: Combined Publishing, 1999), 47.
4. Robert Strauss, "A City Tradition: 'Meet Me at the Iggle,'" *Philadelphia Daily News*, March 9, 1978.

A New Kind of Store

5. Jane M. Von Bergen, "A Marketing Pioneer Gives Way to the New," *Philadelphia Inquirer*, August 28, 1995.
6. John Maass, "The Merchant Pioneer," *Destination Philadelphia* (March–April 1977), 13.
7. Ershkowitz, *John Wanamaker*, 57.
8. Ibid.
9. *Philadelphia Bulletin*, "Wanamaker's Completing a Century of 'Firsts,'" April 2, 1961.
10. Ershkowitz, *John Wanamaker*, 77.

NEW YORK, NEW YORK

11. *The New York Store* (Philadelphia: John Wanamaker, 1907), 26.
12. Ershkowitz, *John Wanamaker*, 127.
13. *The New York Store*, 27.
14. *New York Times*, "Looters at Burning of Wanamaker Home," February 9, 1907.

THE EAGLE HAS LANDED

15. Thomas Hine, "A Center of Commerce, a Place for People," *Philadelphia Inquirer*, August 28, 1995.
16. *Philadelphia Record*, "The Eagle Gleams Once More," September 5, 1940.

ORGAN DONOR

17. Ray Biswanger, *Music in the Marketplace* (Bryn Mawr, PA: Friends of the Wanamaker Organ Press, 1999), 32.
18. Ershkowitz, *John Wanamaker*, 179.
19. Craig Richmond, interview with the author, March 2010.
20. Curt Mangel, interview with the author, May 5, 2010.
21. Ray Biswanger, interview with the author, February 18, 2010.
22. *To-day at John Wanamaker Philadelphia* (Philadelphia: John Wanamaker, 1936).
23. Mangel, interview.
24. Biswanger, *Music in the Marketplace*, 93.
25. Biswanger, interview.
26. *New York Times*, "Wanamaker to have 3 television studios," August 31, 1945.

FAMILY TRUST

27. *Welcome to Philadelphia and John Wanamaker*, 33.
28. William Allen Zulker, *John Wanamaker, King of Merchants* (Wayne, PA, Eaglecrest Press, 1993), 139.
29. "A Famous Merchant," *New York Times*, December 13, 1922.

30. *New York Times*, "John Wanamaker Dies at Age of 84 from Heart Attack," December 13, 1922.

31. Zulker, *John Wanamaker*, 207.

32. Biswanger, *Music in the Marketplace*, 156–157.

33. Zulker, *John Wanamaker*, 162–163.

34. John T. Gillespie, "Wanamaker Kin Battles Board," *Philadelphia Bulletin*, November 3, 1978.

A FLAGSHIP ADRIFT

35. William Zulker, interview with the author, March 12, 2010.

36. Jan Whitaker, correspondence with the author, April 6, 2010.

37. *To-Day at John Wanamaker Philadelphia*.

38. Zulker, interview.

39. *Philadelphia Inquirer*, "Wanamaker's to Open New Men's Shop Soon," August 16, 1932.

40. Bernice Fitz-Gibbon, *Macy's, Gimbels, and Me* (New York: Simon & Schuster, 1951), 157.

41. Ibid., 168.

42. Wanamaker Papers.

43. Christopher Kellogg, interview with the author, January 30, 2010.

44. *Philadelphia Bulletin*, "New War Bond Post Opens," May 19, 1942.

45. *Philadelphia Inquirer*, "Wanamaker's Aids Tin Can Campaign," October 30, 1942.

OFF TO MARKET

46. Lynne Abraham, interview with the author, March 6, 2010.

47. Mercia Grassi, interview with the author, February 11, 2010.

48. Ibid.

OPENING SOME STORES, CLOSING SOME DOORS

49. *Wilmington Evening Journal*, "Wanamaker's Reveals Design of Proposed Ninth Ward Store," September 19, 1947.

50. *Wilmington Evening Journal*, "John Wanamaker Store to Officially Open Today", November 15, 1950.
51. Pat Ciarrocchi, interview with the author, March 5, 2010.
52. Trudy Haynes, interview with the author, February 24, 2010.
53. Louise Wanamaker, interview with the author, January 8, 2010.
54. Kellogg, interview.
55. Wanamaker Papers.
56. Milton Bracker, "Bell Tolls Closing of Wanamaker's as Saddened Staff Toils to the End," *New York Times*, December 19, 1954.
57. Wanamaker Papers.
58. *New York Times*, "The Wanamaker Fire," editorial, July 16, 1956.

CHRISTMAS LIGHTS

59. Kellogg, interview.
60. Sally Starr, interview with the author, February 5, 2010.
61. Kellogg, interview.
62. Joel Spivak, interview with the author, February 9, 2010.
63. *John Wanamaker—the Magic of Christmas* (Philadelphia: John Wanamaker, 1956).
64. *John Wanamaker—Pageant of Lights*, video, Clair Pruett Studios–John Wanamaker's Portrait Studios (Philadelphia: John Wanamaker, 1992).
65. Ibid.

A SIGN OF THE TIMES

66. Haynes, interview.
67. Leon Harris, *Merchant Princes* (New York: Kodansha International, 1994), 379.
68. Ciarrocchi, interview.

AN EAGLE SPREADS ITS WINGS

69. Wanamaker Papers.
70. Kellogg, interview.
71. Alfred Lief, *Family Business* (New York: McGraw-Hill, 1968), 283.

72. Grassi, interview.

73. *Philadelphia Inquirer*, "Wanamaker to Build in New Jersey," February 7, 1961.

74. *Philadelphia Bulletin*, "A Famous Eagle Spreads His Wings," August 12, 1965.

75. Laura Lee, "Wanamaker's and Gimbels Plan Harrisburg Branches," *Philadelphia Bulletin*, April 21, 1968.

Cashing Out

76. Frank R. Veale, *Family Business—The Momentous Seventies* (Philadelphia: Strawbridge & Clothier Press, 1981), 26.

77. Laurence Hooper, "Wanamakers," *Philadelphia Magazine* (April 1989).

78. Ibid.

79. Veale, *Family Business*, 20.

80. Grassi, interview.

81. Trudy Prokop, "S&C Led the List in '73 Retail Sales," *Philadelphia Bulletin*, March 24, 1974.

82. Wanamaker, interview.

83. Trudy Prokop, "Ailing Blum Store to be Sold to N.Y. Liquidator," *Philadelphia Bulletin*, August 8, 1975.

84. Herbert Ershkowitz, interview with the author, February 10, 2010.

85. John T. Gillespie, "Lits Adds to Slump of Parent Company," *Philadelphia Bulletin*, April 3, 1977.

Becoming an Albatross

86. John T. Gillespie, "Wanamaker's Facelifts—$30 million," *Philadelphia Bulletin*, March 13, 1978.

87. Richard P. Hauser, interview with the author, February 15, 2010.

88. Jan Schaffer, "A Rededication to Taste at John Wanamaker," *Philadelphia Inquirer*, January 24, 1982.

89. Arthur Howe, "Ending an Era at Wanamakers of New York," *Philadelphia Inquirer*, August 6, 1983.

90. Hooper, "Wanamakers."

91. Ibid.

A Final Flight

92. Lisa Schwartz, "Shoppers Say 'Buy' to Stern's," *Philadelphia Inquirer*, February 13, 1992.

93. Caroline E. Mayer, "Woodies Enters Bid for Wanamakers," *Washington Post*, September 20, 1986.

94. Hauser, interview.

95. Barbara Demick, "$185 Million Historic Renovation Slated for Wanamaker Building," *Philadelphia Inquirer*, March 9, 1988.

96. Barbara Demick, "The Eagle Becomes an Albatross," *Philadelphia Inquirer*, January 16, 1989.

97. Barbara Demick, "Wanamakers No Longer for Sale," *Philadelphia Inquirer*, February 8, 1989.

98. Susan Warner, "The Eagle Seeks New Wings," *Philadelphia Inquirer*, June 24, 1991.

99. Cynthia Mayer, "What's In a Name? A City's Soul," *Philadelphia Inquirer*, June 25, 1995.

100. Jacqueline Love, "A Loss of a Great Landmark," *Philadelphia Daily News*, June 22, 1995.

101. John F. Morrison, "Wanamakers—Biggest Sale Ever," *Philadelphia Daily News*, June 22, 1995.

Afterlife

102. Jane M. Von Bergen, "He's Got Plans for Hecht's," *Philadelphia Inquirer*, September 10, 1995.

103. Andrew Cassel, "A Center City Hecht's May Not Help the Downtown Much, But It Won't Hurt," *Philadelphia Inquirer*, August 13, 1995.

104. Maureen Graham, "Good-Byes, Good Buys at Store," *Philadelphia Inquirer*, February 2, 1997.

105. Jane M. Von Bergen, "High Hopes and Red Roses," *Philadelphia Inquirer*, August 4, 1997.

106. Ibid.

COURTESY, INTEGRITY, MUTUALITY

107. Richard Longstreth, *The American Department Store Transformed—1920–1960* (New Haven, CT: Yale University Press, 2010), 117.

108. Peter Richard Conte, interview with the author, July 8, 2010.

FROM THE CRYSTAL TEA ROOM

109. Hawaiian salad, Cheese Pie and Eggs with Mornay Sauce recipes as listed in Anna Wetherill Reed's *The Philadelphia Cook Book of Town and Country* (New York: Random House, 1963). All recipes listed as from the John Wanamaker Crystal Tea Room.

About the Author

Michael J. Lisicky was born in Camden, New Jersey, and grew up shopping in Strawbridge & Clothier, Gimbels, Lits and John Wanamaker. He resides in Baltimore where he is an oboist with the Baltimore Symphony Orchestra. He is active with the Preservation Society of Fell's Point and serves as the community's Towne Crier. In demand as a lecturer on department store history, Mr. Lisicky helps run an Ask the Expert column on the website http://www.departmentstorehistory. net. He is the author of the best-selling book *Hutzler's: Where Baltimore Shops*, which was also published by The History Press.

For more information on the Friends of the Wanamaker Organ, visit www. wanamakerorgan.com.

Visit us at
www.historypress.net